ROSYTH
THROUGH TIME
Martin Rogers

AMBERLEY PUBLISHING

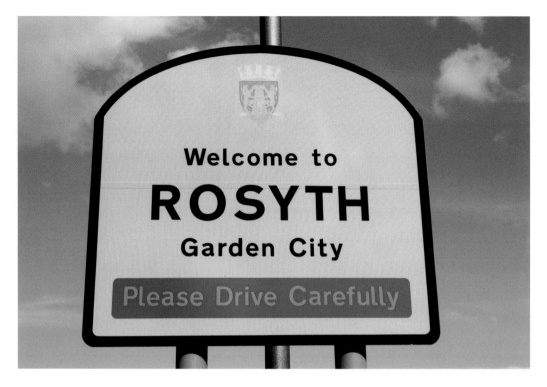

Rosyth's origins as a Garden City have largely been forgotten but, in recent years, attempts have been made to change this. In about 2003, these signs were erected on the roads entering Rosyth. At about the same time, the Rosyth Garden City Association was formed and it actively promotes Rosyth's heritage through talks and exhibitions.

First published 2009

Amberley Publishing Plc
Cirencester Road, Chalford,
Stroud, Gloucestershire, GL6 8PE

www.amberley-books.com
Copyright © Martin Rogers, 2009

The right of Martin Rogers to be identified as the Author of this work has been asserted in accordance with the Copyrights, Designs and Patents Act 1988.

ISBN 978 1 84868 736 3

British Library Cataloguing in Publication Data.
A catalogue record for this book is available from the British Library.

Typeset in 9.5pt on 12pt Celeste.
Typesetting by Amberley Publishing.
Printed in the UK.

Introduction

Compared to its neighbours of Dunfermline and Inverkeithing, the town of Rosyth has only a short history. Work on building the original Garden City of Rosyth began in 1915 and some 1,600 houses were completed by 1918. There have been a lot of changes in Rosyth in the intervening ninety years or so – some very obvious and others less so. In this book, photographs of Rosyth from the past are shown with modern views of the same scene to illustrate some of these changes.

After completion of the initial 1,600 houses, a further 100 semi-detached houses were built in the early 1920s together with shops, churches, masonic lodges, a hotel, a cinema and the Parkgate Institute. It was not until the late 1930s that there was any further significant housing and this was the Wemyss Street and Nelson Street development by the Town Council, completed in 1939. This was quickly followed by new houses in King's Road and the building of the Dollytown estate. Substantial new housing developments were carried out in the late 1940s, 1950s and 1960s, including married quarters for Royal Navy personnel in the Castle Road and Hilton Road area. The 1970s saw the creation of the Primrose and Whinnyburn Estates, the redevelopment of the Dollytown area and yet more married quarters off Castle Road. Buildings were erected around Pitreavie Castle when it was taken over by the Royal Air Force in 1938 and married quarters were built at a later date. Since the 1980s, a number of private housing schemes have been built including the very substantial estate of Peasehill. As most of the residents in Rosyth relied on the Dockyard for employment, there was little in the way of factories and offices in Rosyth. Lyle & Scott was the first business of any size to open premises in Rosyth (in 1962). In more recent times, others have followed – Sky and Lexmark, for example.

So what changes will you see when you look at these photographs old and new? In some respects the original Garden City of Rosyth has not changed a great deal, with the original houses still existing

within the same road layout. However, the outward appearance of the houses has changed – quite considerably in some cases. This was partly the result of modernisation work carried out by the Scottish Special Housing Association in the mid-1980s but it was the 'right to buy' policy introduced by Margaret Thatcher's government in 1980 that had the most significant effect. Tenants were able to buy their houses and set about harling them; erecting porches, extensions and garages; replacing windows and doors; and removing hedges and front gardens. Television aerials and satellite dishes became prominent features on buildings.

One major vehicle of change (pun intended) has been motor transport. The early postcard views show roads almost empty of vehicles but in most of the modern views, vehicles are very prominent. It is not only the vehicles themselves but also the 'road furniture' provided to aid, control and regulate traffic. There are more lamp posts, pedestrian crossings, white and yellow lining, traffic signs, speed humps and speed cushions, and more provision for car parking. All play their part in the changing face of Rosyth. The town of Rosyth has expanded substantially over the years with areas which were once fields and open spaces now covered by houses and business premises and, in a few cases, the reverse has happened. In some scenes, trees which were saplings are no longer there and in others, the trees have matured and spread their branches to such an extent that I found it difficult to take some of the modern photos.

The sequence of photographs may seem rather random but there is logic to it. The book begins with photographs taken along the main routes through Rosyth – Admiralty Road (including the Crossroads); Castlandhill and Queensferry Road; Ferrytoll Road and Hilton Road; and Castle Road and King's Road. There are then photographs from various areas of Rosyth. I have also included some photos of Pitreavie as there were close links between Pitreavie and Rosyth in days gone by. I have not included any photos of the Dockyard and Naval Base area as I hope to make that the subject of another book at a future date.

I hope you enjoy this trip down memory lane. Whether you are a resident of Rosyth or living further afield, it will give you some insight into how Rosyth has changed and developed over the years.

Martin Rogers, 2009

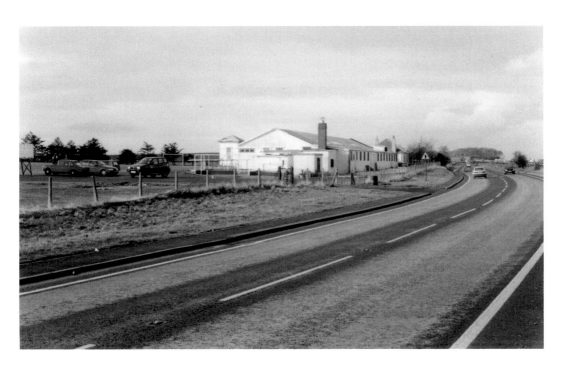

Fleet Grounds Pavilion

Lying to the south of Admiralty Road at its western end were the Royal Navy's Fleet Grounds where sailors of the fleet could take part in sporting activities. This photo was taken in 1995 and shows the pavilion at the fleet grounds shortly before it was demolished. The site of the pavilion is now part of the grounds of the Lexmark factory, which was opened in 1996 and closed in 2006 (see inset). It currently stands empty awaiting a buyer.

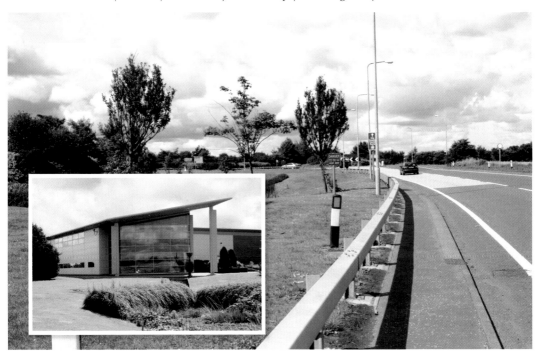

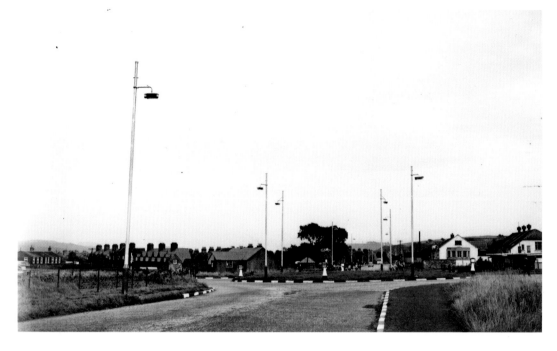

Approaching Rosyth from the West
This is the roundabout at the Castle Road end of King's Road as viewed from the west. This and some later photos were taken in 1954 by Morris Allan following the installation of new street lighting. In the photo are the Co-op's Tin Store at the top of Backmarch Road and the Dockyard Club, both of which feature in later photographs. The houses on the right in the modern photo were built in 1989. *(Photo by Morris Allan)*

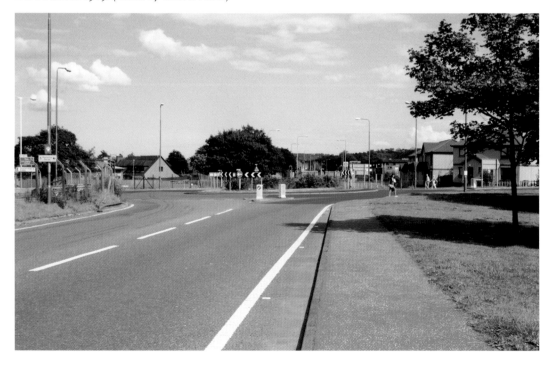

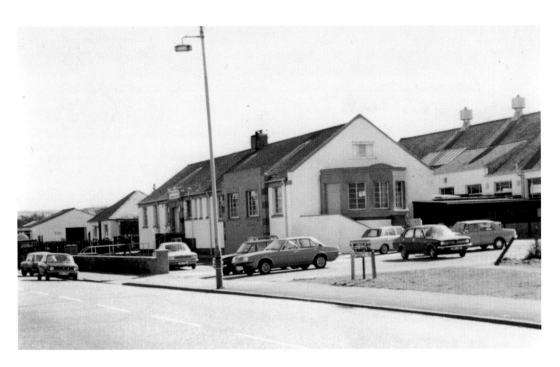

Dockyard Club

The Dockyard Club was founded in 1916. It met in premises in Castle Road, probably in the building which later became the Chart Depot (see p. 51). This building in Admiralty Road was opened in 1936. It was badly damaged by fire in 1976 and the photo below is of the new building opened the following year. The Club closed and when the building was sold it was renamed The Yard. *(Edith May collection)*

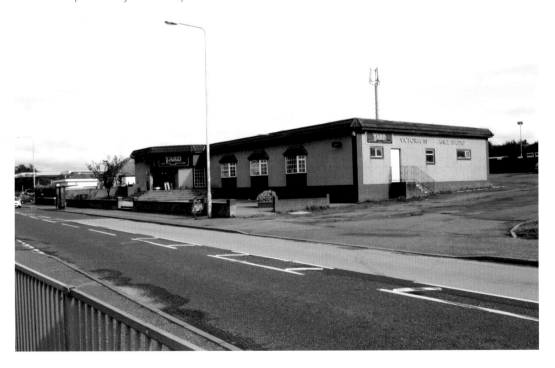

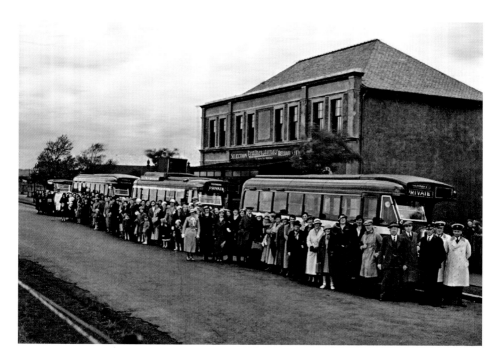

Featherstones' Shop

Featherstones' were a company from Rochester in Kent who established a branch in Rosyth for the benefit of many of their loyal customers who had been transferred from Chatham Dockyard. They operated from a wooden hut until this permanent building was opened in 1925. The firm organised an annual outing for their staff and customers and a party of 115 are pictured here in 1935 setting off on an outing to Loch Tay. The shop was taken over by Lawrie & Wilkie in about 1938, later changing its name to Wilkie's. As can be seen from the photo below, it is now a Spar shop. *(Photo by Norval)*

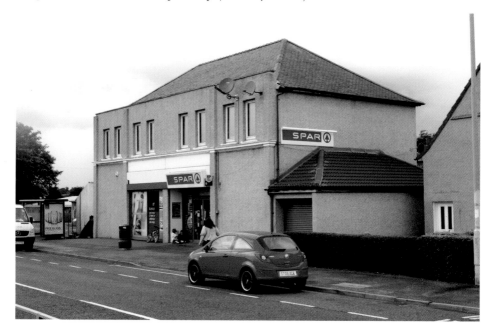

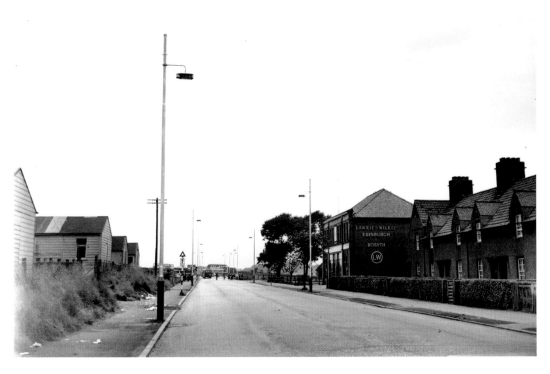

Admiralty Road near its junction with Backmarch Road
Lawrie & Wilkie's shop can be seen here on the right of this photo taken in 1954. On the left side of the photo are wooden huts erected during the Second World War and these were replaced in about 1960 by the petrol filling station. *(Photo by Morris Allan)*

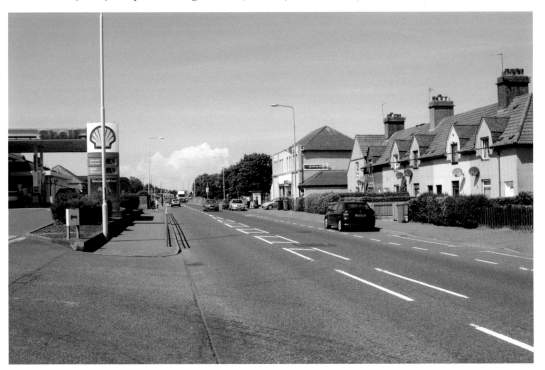

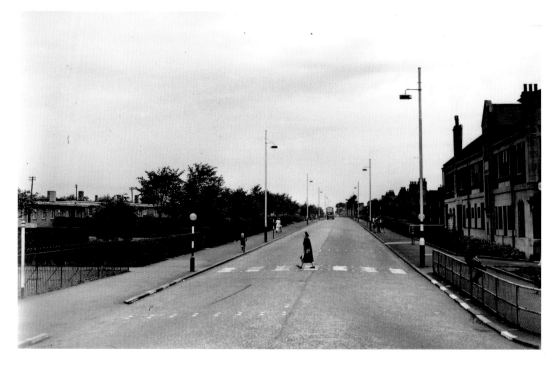

Admiralty Road near the Crossroads
Also taken in 1954, this is somewhat reminiscent of the Beatles' *Abbey Road* album. At the time the photo was taken, the building on the right was Rosyth Police Station (now the Ex-Servicemen's Club). On the left can be seen some of the Dollytown houses. *(Photo by Morris Allan)*

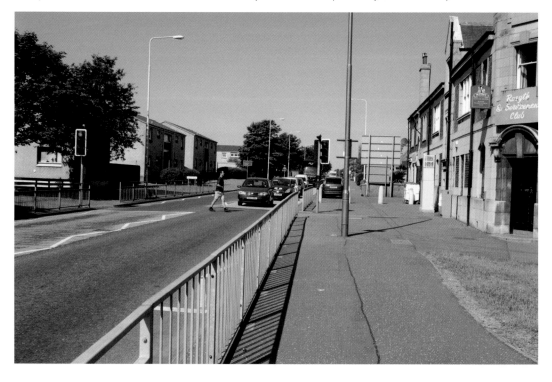

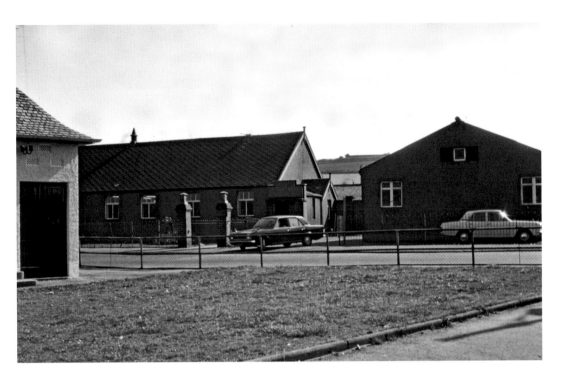

Ex-Servicemen's Club

Taken in 1971, this photo shows the Ex-Servicemen's Club on the south side of Admiralty Road opposite the Kiosk. This building was vacated in 1971 and the site was incorporated in the redevelopment of the Dollytown area. St Andrew & St George Episcopal Church had a temporary building on this site in 1917 before moving to their permanent church in King's Place in 1926.

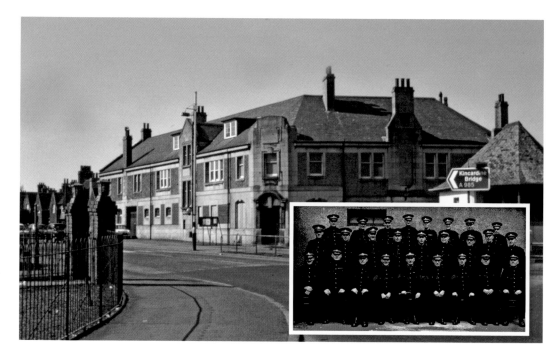

Police Station at the Crossroads

This building was opened in 1943 and the inset photo shows the Rosyth Police Force in 1944. There are a lot of them and perhaps this photo includes special constables. The western end of the building was used by the Trustees' Savings Bank until 1981 when they moved to their present premises in the Queen's Buildings. This photo was taken in 1971, a year after the Police moved to smaller premises beside the Co-op at the Crossroads. That building too was closed and the only permanent police presence in Rosyth is the unmanned call point in Crossroads Place. (See photo on p. 15)

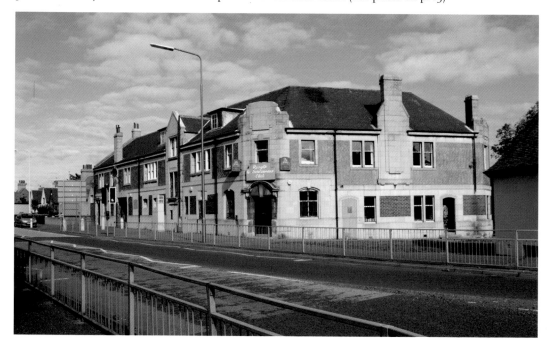

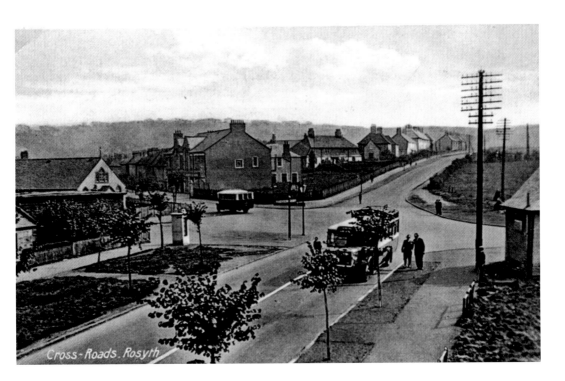

Cross-Roads, Rosyth

Rosyth Crossroads

This photo was taken from Queensferry Road in about the mid-1930s before any roundabout existed. An early telephone box is seen outside Fair's Shop and the only vehicles are the two buses. The current photo was taken closer to the junction to avoid the traffic signals at the pelican crossing and to get a better view over the barrier.

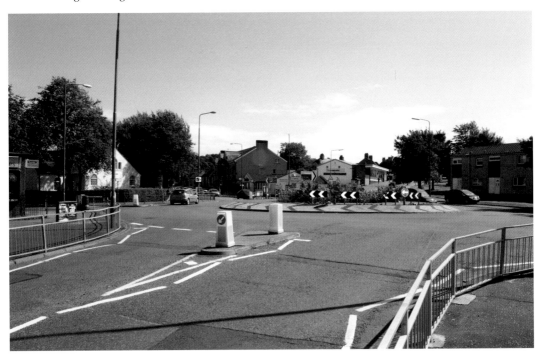

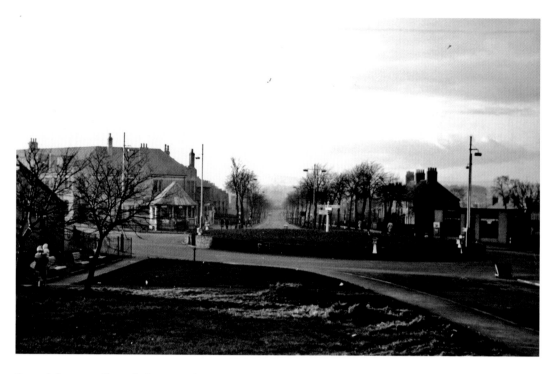

Roundabouts at Rosyth Crossroads

The first roundabout at the Crossroads (more of a traffic island) was erected in 1938 and the design has changed a number of times over the years. The photo above was taken in about the late 1950s and shows my favourite: a brick-built version topped by a bed of red roses. *(Photo by R. Whitehead)* A low-level roundabout was installed in 1973, which is probably the one shown below in this photo from 1978.

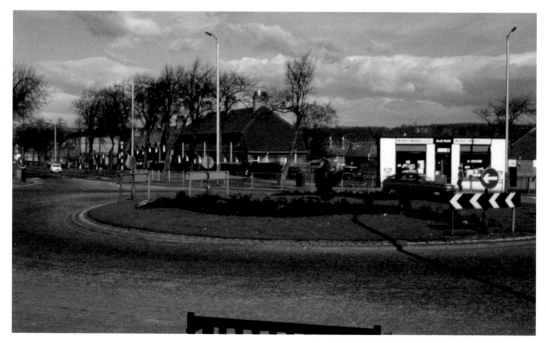

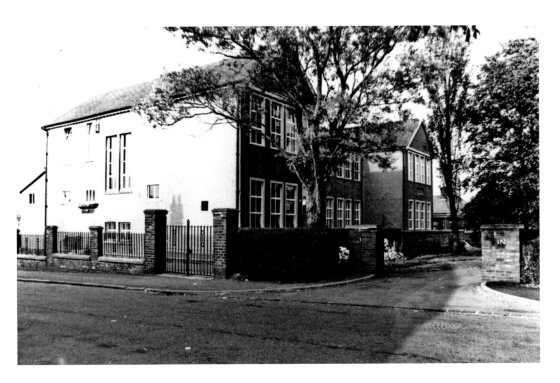

St John's RC Primary School

The school was situated next to St John & St Columba's RC church in Crossroads Place and this photo of it dates from 1982. In 1988 the school was replaced by a new school in Heath Road (see p. 79) and the site was used for housing and a Police call point.

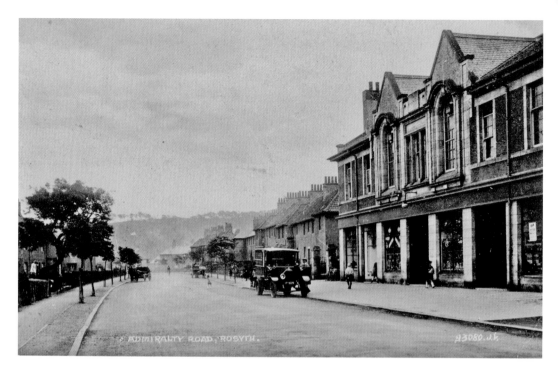

Dunfermline Co-op Premises at Crossroads

The Co-op built these premises in 1920. As well as shops, there was a large hall, which in its early days was used as a cinema. In 1922 the hall became available for let for dances, concerts and public meetings and was commonly referred to as 'The Snakepit'. The building was converted into flats in 1999. *(Valentine's PC)*

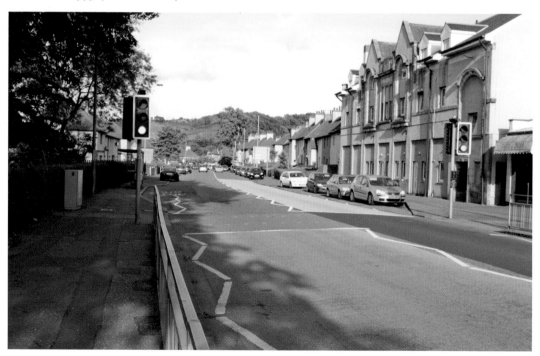

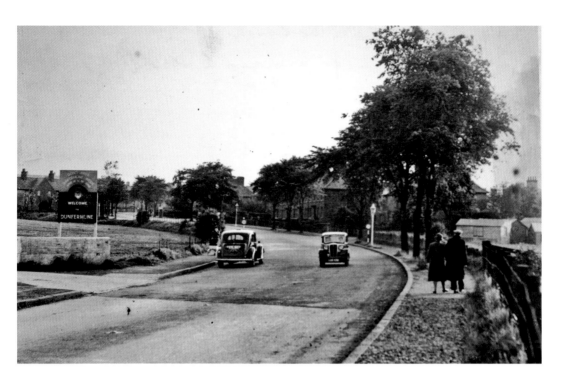

East End of Admiralty Road

This is a view looking in the direction of the Crossroads from the outskirts of Rosyth. On the left is the entrance to Rosyth Quarry. When the approach roads to the Forth Bridge were built in the early 1960s, this section of Admiralty Road was diverted to connect to the new interchange and part of it disappeared under the motorway and slip roads. For this reason, the modern view below had to be taken much closer to the houses. *(Photo by Morris Allan)*

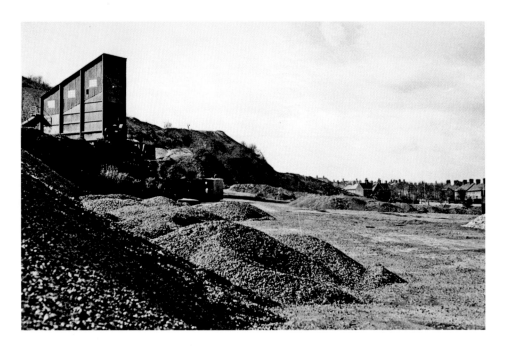

Rosyth Quarry

On the eastern outskirts of Rosyth was Rosyth Quarry. The view above was taken in 1961 and shows some of the quarry buildings seen when approaching Rosyth from Inverkeithing. Houses in Admiralty Road can be seen in the distance. The A90/M90 road to the Forth Road Bridge now cuts across Admiralty Road close to the site and this must have been a contributory factor, if not the reason, for the closure of the quarry. The area where the stone was quarried still exists and is a favourite spot with rock climbers. *(Photo by J. Wright)*

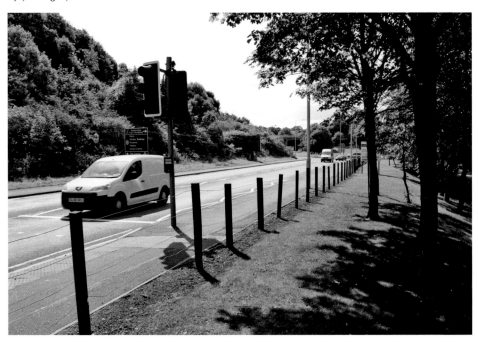

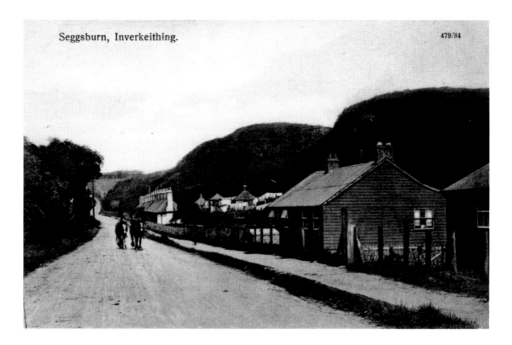

Seggsburn Cottages

We turn now to the Castlandhill and Queensferry Road route through Rosyth. On the south side of Castlandhill were the Seggsburn Cottages, which were built about the late 1890s. There were other buildings erected in this area including a First World War army camp. The cottages were demolished in the early 1960s having had closure orders served on them. As can be seen from the photo below, the cottages would have been affected by the engineering works for the approach roads to the Forth Bridge.

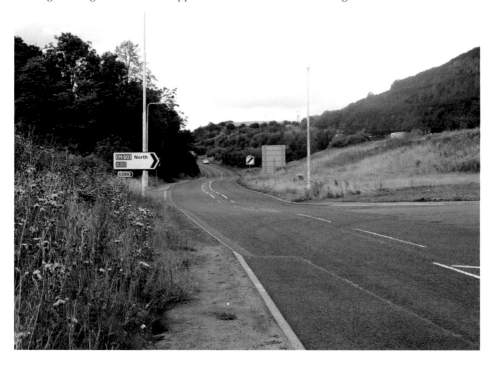

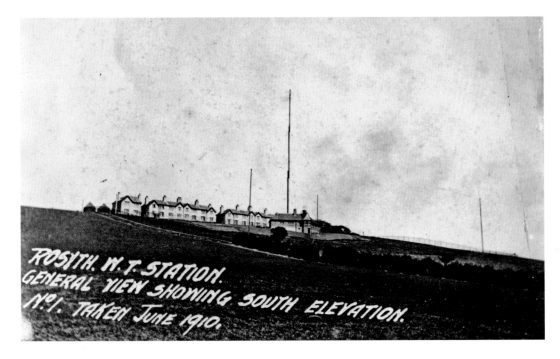

ROSYTH W.T. STATION.
GENERAL VIEW SHOWING SOUTH ELEVATION.
No. 1. TAKEN JUNE 1910.

Castlandhill WT Station

The Admiralty established a Wireless Transmitting Station on Castlandhill in 1910, some years before the Dockyard was operational and the Garden City was built. Aerials or masts on Castlandhill have been an ever-present feature of the landscape since then. Although the Royal Naval use may have ceased, the masts now have a role to play as part of the nationwide telecommunications network.

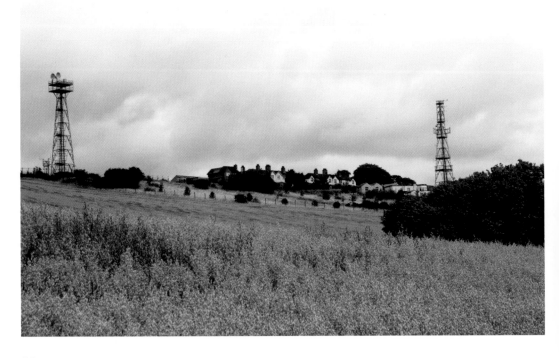

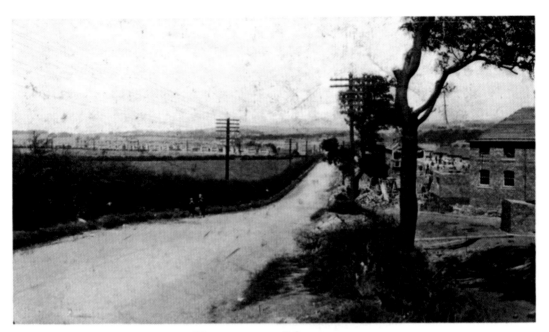

Rosyth from Castlandhill.

Top of Castlandhill Road

To the best of my knowledge, this is the only photo which shows building work under way on the original Garden City houses. The house in the foreground, which is substantially completed, is at the end of Hillwood Terrace. The photo dates from about 1917. The land on the left hand side of the road was used for building the Dollytown housing estate during the Second World War. *(Davidson's PC)*

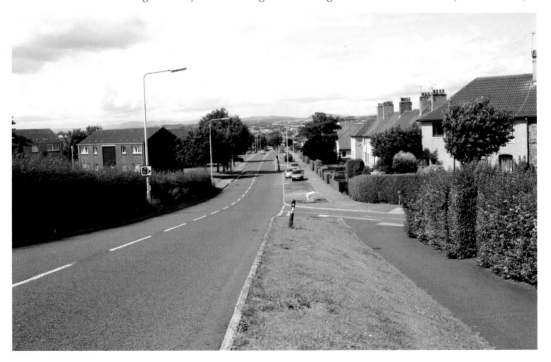

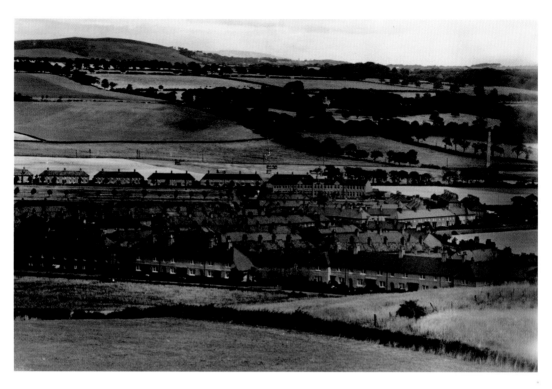

East Rosyth from Castlandhill
I only came across this interesting view of Rosyth this year. It dates from about the mid-1920s. Castlandhill Road is in the foreground and Park Road School is in the centre. The tall chimney on the right of the photo was the Brickworks' chimney.

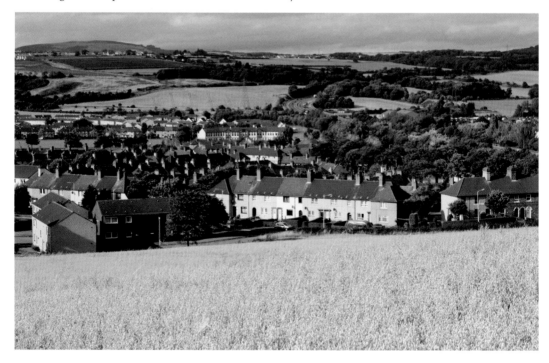

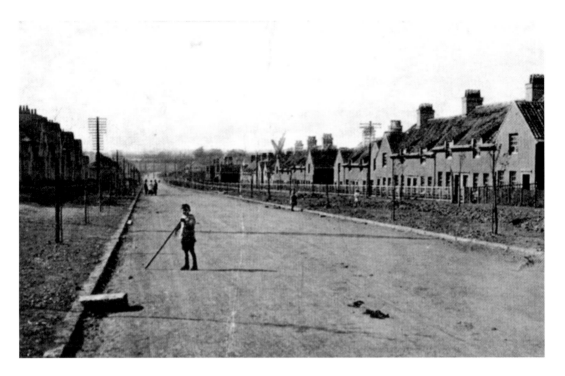

Queensferry Road at the Crossroads

This view up Queensferry Road was probably taken about 1920, only a few years after the building of the houses. Trees and hedges have been planted but have not yet matured, unlike the bottom photo where the trees largely obscure the view up the road. Traffic was minimal and the boy in the photo could stand in the road quite safely. Photographing Elliot with his bike for the bottom photo required some careful timing because of the traffic. *(Davidson's PC)*

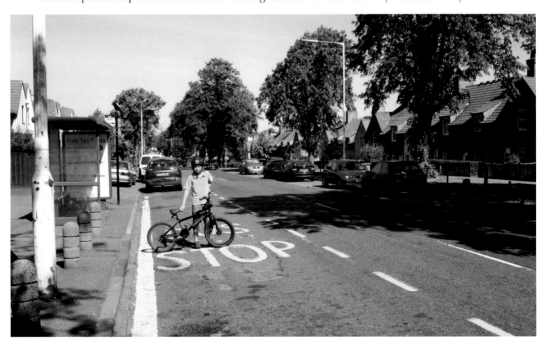

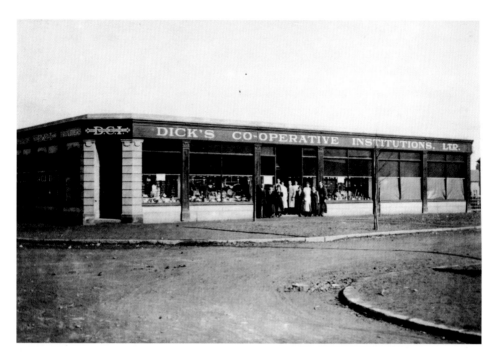

Dick's Co-operative in Queensferry Road
The design of Rosyth Garden City did not provide for a town centre as such but rather for small groups of corner shops through the town. The Queensferry Road/Parkgate junction was one such location. This was the Dick's Co-op building on the south-east corner of the junction, which opened in 1918. The bottom photo is a view inside the shop at a time before the introduction of self-service. Although run along somewhat similar lines to the wider Co-op movement, Dick's Co-op was a private business. The photos were taken in about 1920.

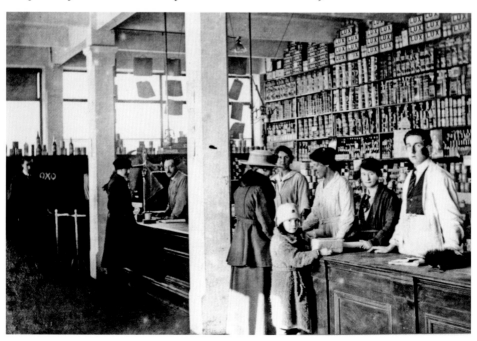

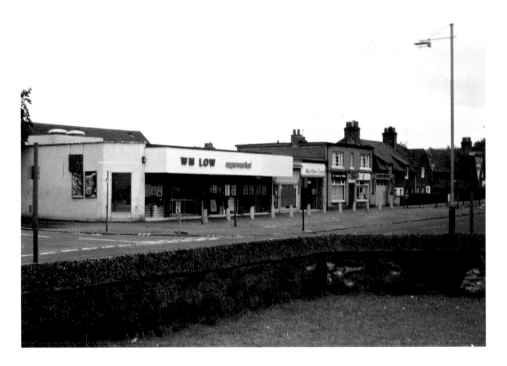

William Low

Dick's Co-op closed in 1954 and the building in Rosyth was sold to Mr Duncan of Townhill. At a later date, it was bought by William Low. In 1969, Low's purchased the former Methodist Church premises in Parkgate allowing them to expand the store and create a supermarket. This photo of the supermarket dates from 1979. With the opening of their new store near the Halt in 1982, Low's sold the building and it opened as a bingo hall the following year. The building (or perhaps site) is about to enter a new chapter in its life as the bingo hall is to close down.

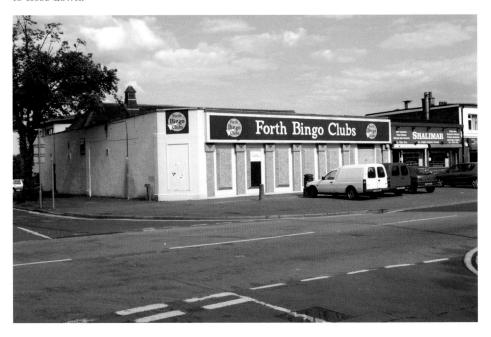

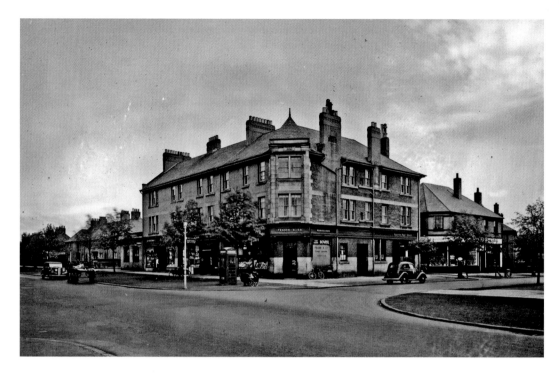

Shops at Queensferry Road and Parkgate Junction

On the opposite corner from Dick's Co-op was this block of buildings which was erected progressively over a number of years from 1917 until about 1926, the date which is displayed on the building. Shops included Scott the chemist, Reid the stationer and Fraser the grocer. Around the corner in Parkgate itself was the Anderson & Campbell building erected in 1934.

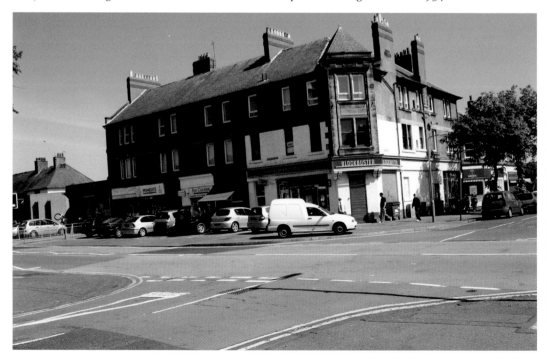

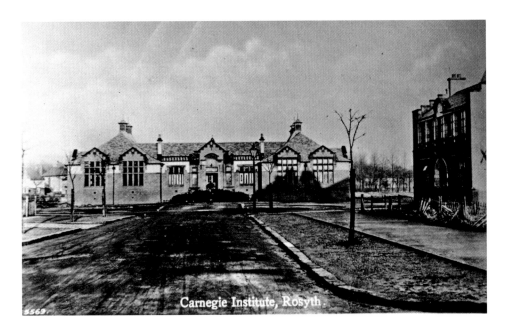

Carnegie Institute, Rosyth.

Parkgate

In Parkgate was the Carnegie Institute (now called the Parkgate Community Centre). Rosyth was within the extended boundaries of the Burgh of Dunfermline and, by virtue of this, enjoyed the benefits of the largesse of the Dunfermline Carnegie Trust. The Trust operated a temporary institute near Park Road School until this permanent building was opened in 1926. On the right, is the Masonic Lodge No. 1159. The building was demolished in 2006 and, some three years later, a block of flats now occupies the site. *(J. B. White PC)*

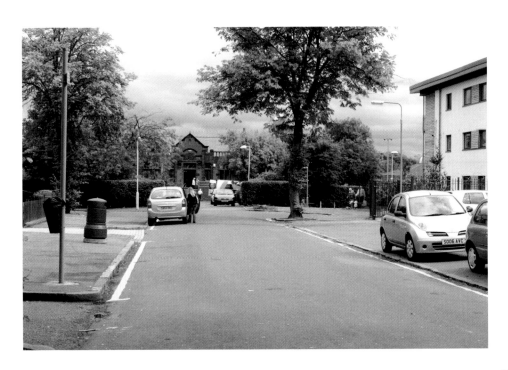

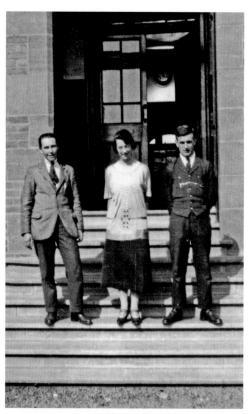

Parkgate Institute
The photo to the left shows some of the staff at the Carnegie Institute shortly after it opened in 1926. In the centre is Lizzie Simpson and, on the right, Charlie Girdler. Pictured below are some of the present staff – Heather McGlinchey, Fiona Selley, Ronnie Watson, Mari Brearley, and Sharron Clelland, with Jean Clark (Recreation Development Officer).

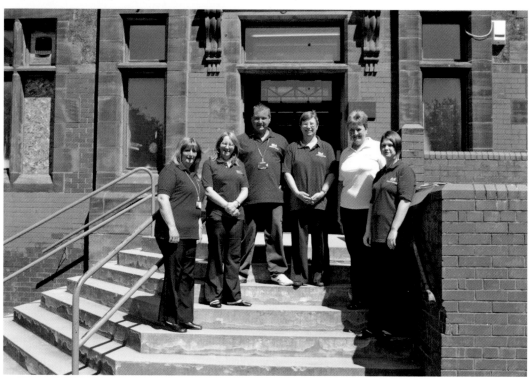

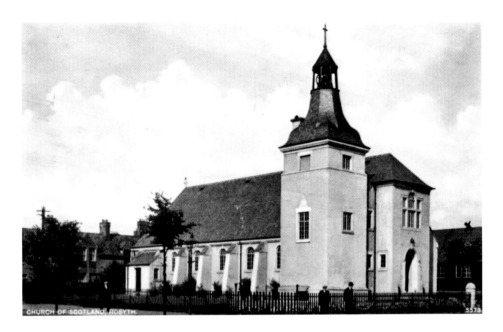

Rosyth Parish Church

From about 1917, church services were held in the wooden hut just visible on the right-hand side of the photo. The permanent building was opened in 1931 with the hut continuing in use as a church hall until replaced by a permanent hall in 1956. Visible on the end wall of the new hall seen in the photo below is the clock erected by Rosyth Community Council to mark the Millennium. The hall continues to be used for church and other activities but the church itself is not in use at present. Services are held at the former naval church, St Columba's, in south Rosyth. *(J. B. White PC)*

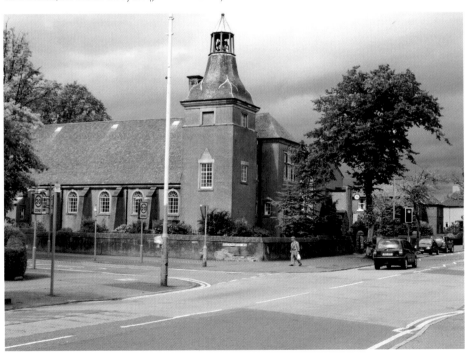

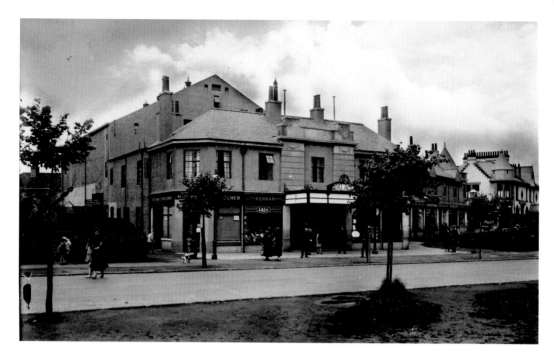

Palace Cinema and Palace Buildings

When this photo was taken in the mid-1920s, cinemas played a much more significant part in people's lives. The Palace Cinema opened its doors at the end of 1921 and continued in use until June 1971, although latterly on a part-time basis interspersed with bingo sessions. The Palace Buildings' shops were opened in about 1922 and early occupants were Hugh Black; C. Tazioli, restaurateur; I. Fisher, newsagent; C. & J. Anderson, confectioner; Samuel Rigdon, grocer; and M. Gonelli, confectioner. *(J. B. White PC)*

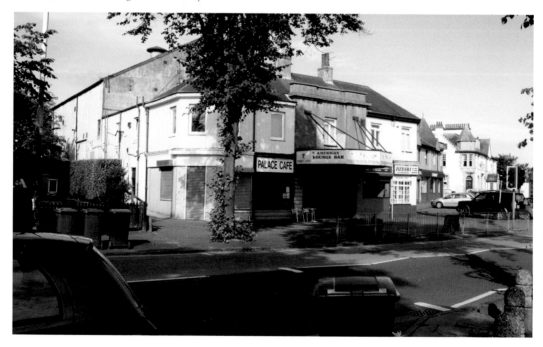

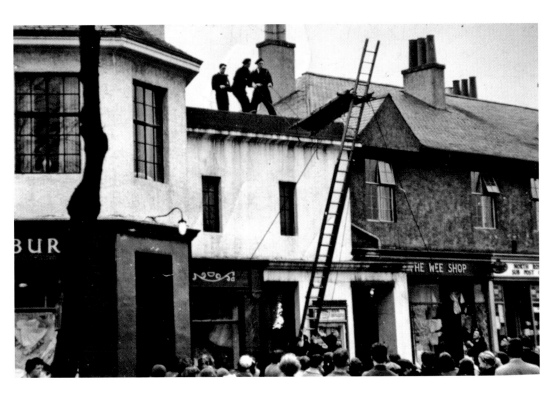

Civil Defence Exercise
Very little is known about this photo. It appears to have been a Civil Defence exercise probably in the early 1950s. The location is the Palace Buildings and there are a number of familiar names visible on the shop fronts. *(Edith May collection)*

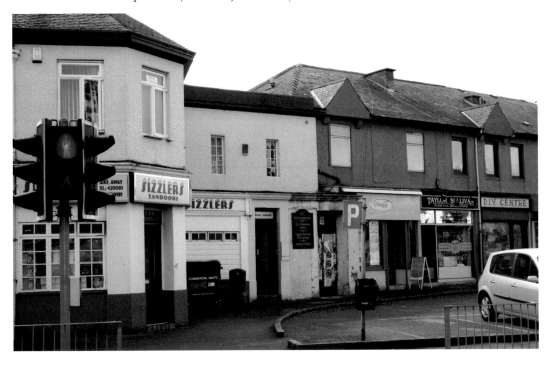

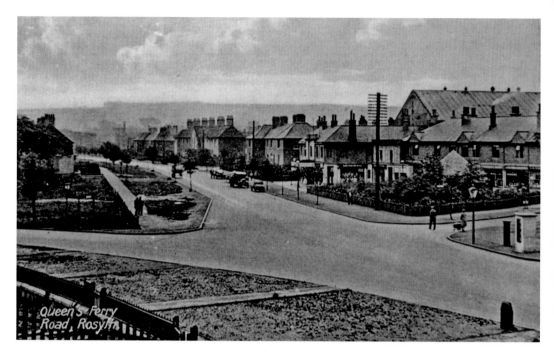

The Palace Area

This view probably dates from the early 1930s. There were very few cars on the road at that time. Hidden in the shrubbery at the right-hand edge of the photo is the ladies' public toilet. The equivalent gents' toilet can be seen on the next page. The open land on the left edge of the photo is where the Queen's Buildings now stand.

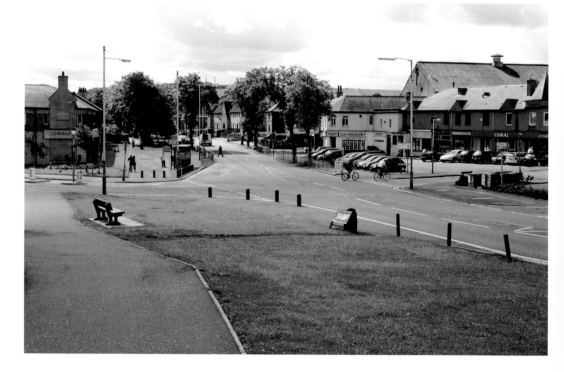

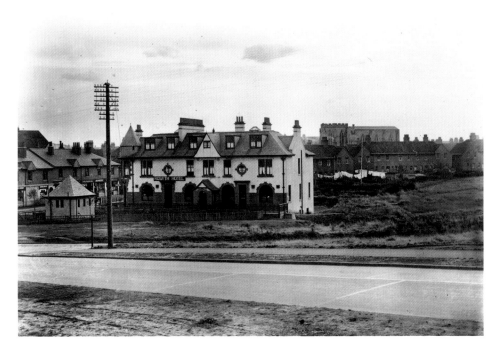

Gothenburg Hotel

There was a strong temperance movement in Rosyth and, in its early years, Rosyth was a 'dry' town with no licensed premises. A number of businesses which applied for licences were refused and the Gothenburg Hotel, which opened in 1921, was the first building to be given a licence. This view from the late 1920s is of particular interest as it shows the vacant land lying to the west of the hotel. This land was not developed for housing until the early 1960s. The top of St Andrew & St George Episcopal Church can be seen on the right of the photo. The small building on the left of the photo is the gents' toilet.

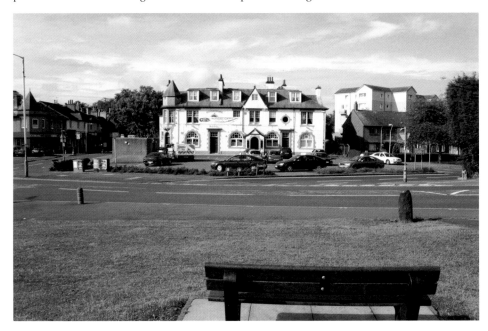

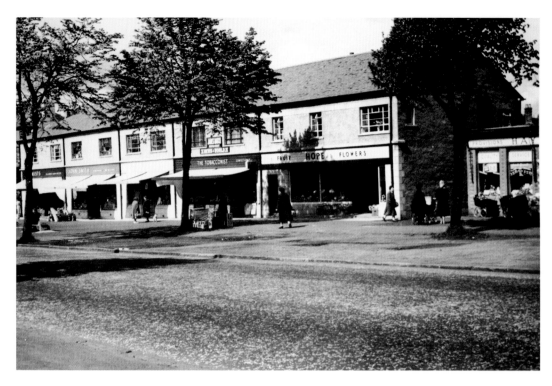

Queen's Buildings

The buildings are named after Queen Elizabeth who acceded to the throne in 1952 and was crowned in 1953. Although the date 1955 appears on the buildings, they were not opened until 1956, which is probably about the date of the top photo. *(Photo by J. Wright)*

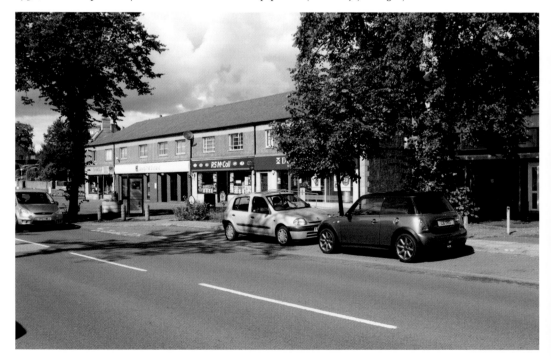

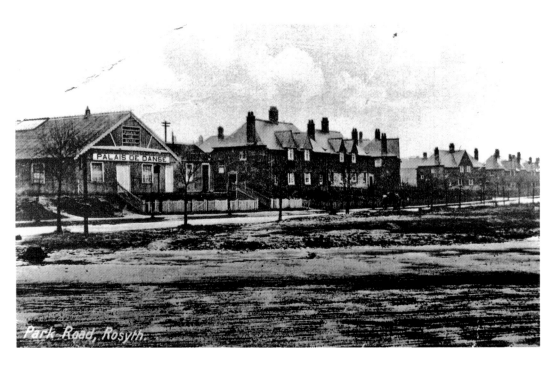

Palais de Danse

The dance hall was situated where the Good News supermarket stands today. The building had formerly been used as a canteen in Tin Town and when it closed at the end of 1919 it was re-erected on this site. It was opened as a Palais de Danse in 1922 and closed in about 1926. The Good News supermarket building was previously used as a car showroom for Will's garage and Jean, the hairdresser had a shop there.

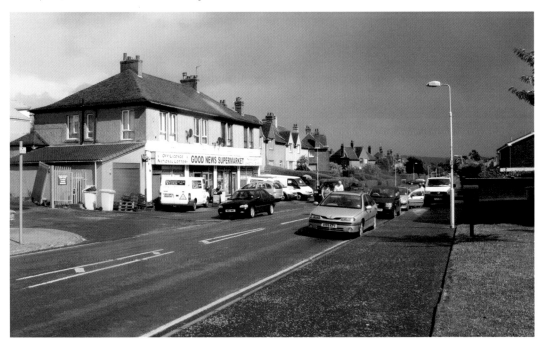

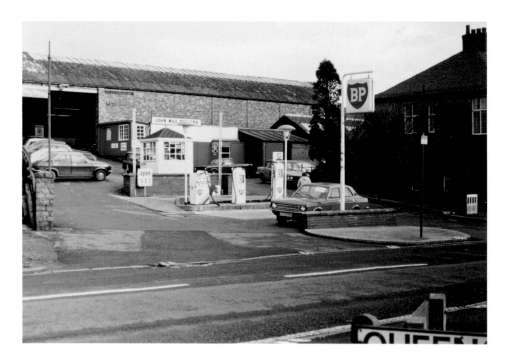

Will's Garage

John Will's was a long-established business in Rosyth. This was the main centre of operations but they also operated petrol filling stations in other parts of Rosyth at various times. This photo was taken in 1981. As can be seen from the bottom photo, the premises have now been taken over by Pandaprint. The flats on the left of the photo date from the mid-1920s and, for a long time, were some of the very few private houses in Rosyth. The anchor in the foreground is a reminder of Rosyth's links with the Royal Navy.

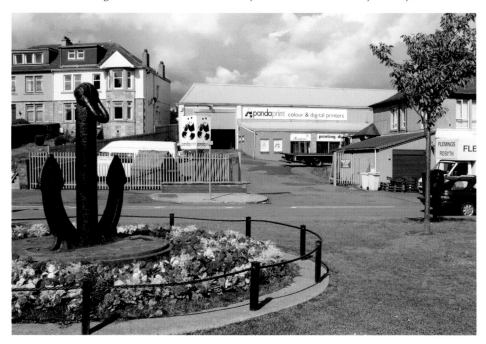

Wilderness Cottage

Standing on the corner of Woodside Avenue was Wilderness Cottage, taking its name from the Wilderness Woods behind. This was part of the Pitreavie Estate and was lived in by Mrs Henry Beveridge until her death in 1935. In about 1945, it was bought by the Methodist Church and was renamed Wesley House. It operated as a canteen for a number of years principally for the benefit of the tiffies (artificer apprentices) from HMS *Caledonia* and also as a meeting place for Church organisations. This photo by J. Wright dates from 1958. The building was demolished in 1969 to make way for the new Church building shown below.

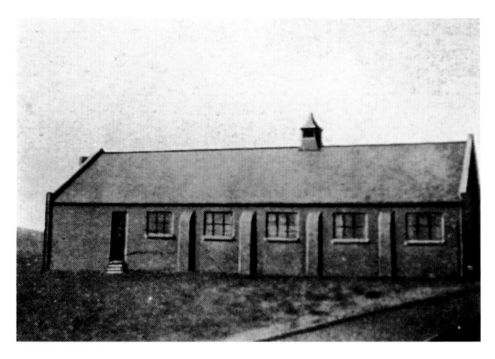

Baptist Church

The Baptist Church building was opened in 1923 and this early photo of the church appeared in *The History of Baptists in Scotland from Pre-Reformation Times,* a book by Rev. George Yuille published in 1926. A wooden hall erected in 1955 was replaced by this permanent building opened at the end of 1990.

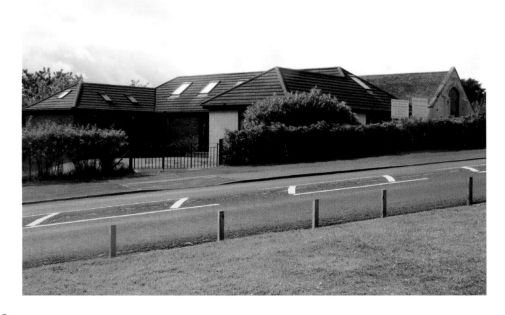

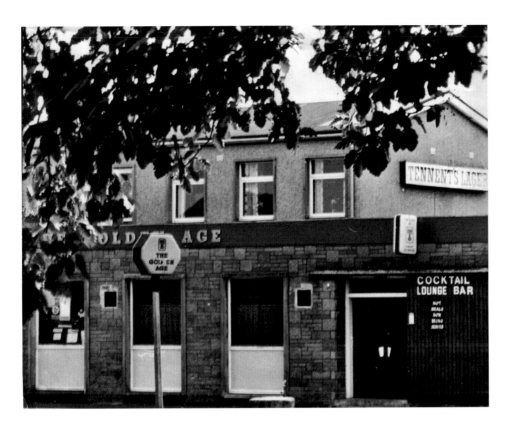

The Golden Age

The triangle of land at the junction of King's Road and Queensferry Road lay unused for many years. The Golden Age was built on part of the land in 1963 and a petrol filling station operated from the northern part of the site. The Golden Age was renamed Cleo's in 1985.

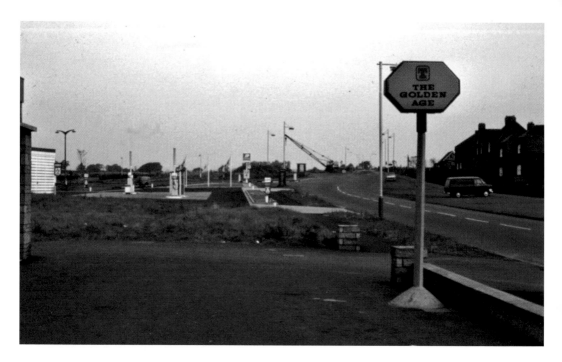

Petrol Filling Station near the Halt

This is a view from outside the Golden Age looking north towards the Halt railway bridge. Work was underway at that time to widen the bridge from single to dual carriageway. The petrol filling station and other unused land between Queensferry Road and King's Road was bought by William Low for a supermarket which opened in 1982. The William Low organisation was bought by Tesco in 1994 and the supermarket is now operated by them as a Tesco Metro store.

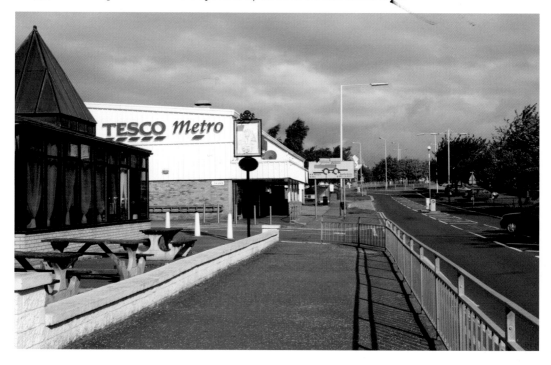

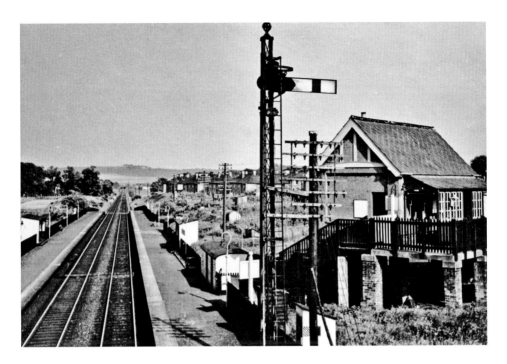

Rosyth Halt Station

The station was opened in 1918 and, as it did not have the full range of station facilities, was designated a 'Halt'. This photo is full of memories for me. I started commuting to work in Edinburgh in the mid-1960s when there were still some steam trains operating. Who remembers old Wullie who manned the station for years? The ticket office was demolished in 1999 and many other changes have taken place since as can be seen from the photo below. Although 'Halt' has been dropped from the station name, this is still the popular name for this end of Rosyth. *(Photo by Mr Salter)*

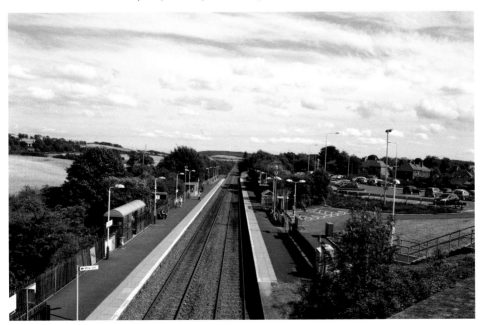

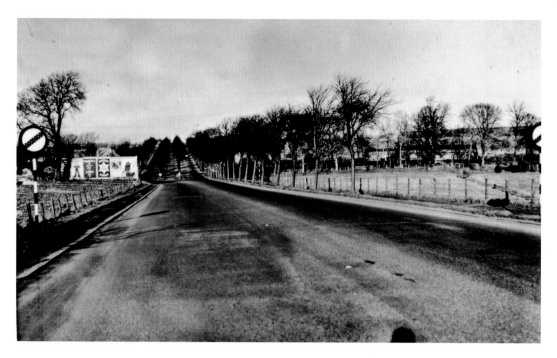

Bottom of Rosyth/Dunfermline Dual Carriageway
This 1961 photo shows the south end of the dual carriageway between Dunfermline and Rosyth, which finished roughly at the entrance to Pitreavie Castle. The central reservation was formerly used by the trams before becoming a cycle track. All of the area between the photographer and the start of the dual carriageway is now occupied by the Pitreavie roundabout. The modern photo below is from near the Halt railway bridge looking north.

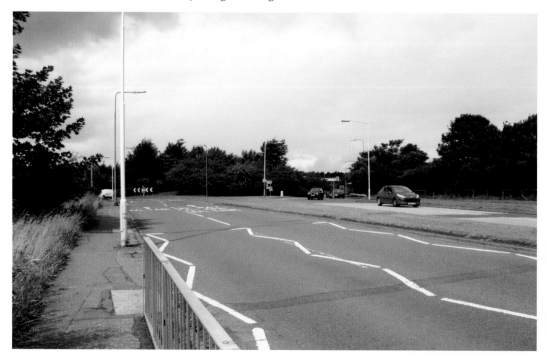

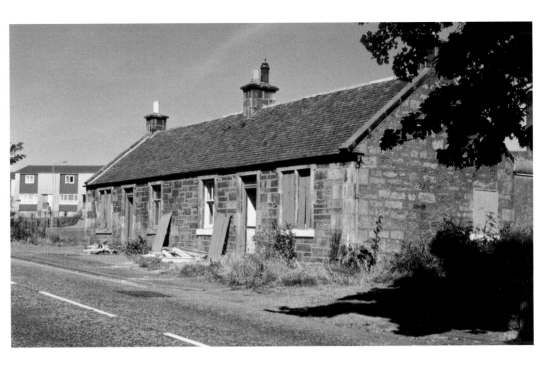

Orchardhead Cottages

We move now to South Rosyth and travel along Ferrytoll Road and Hilton Road. Most farms had cottages for some of their key workers and these are Orchardhead Cottages on Ferrytoll Road lying to the east of its junction with Grampian Road. The cottages had been boarded up and when this photo was taken in 1978, they were about to be demolished.

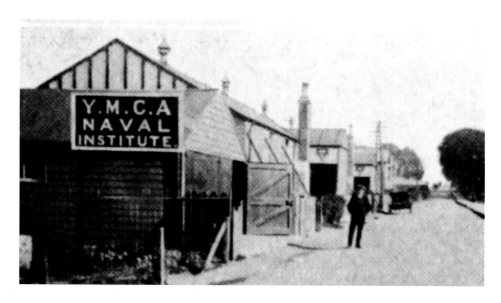

Young Men's Christian Association

At the west end of Ferrytoll Road were extensive premises erected by the YMCA in 1915. The only photo of these buildings which I have come across is this rather poor one taken from the 1916/17 annual report of the YMCA in Scotland. Until a few years ago, the site was occupied by Aggie Weston's (Royal Sailors' Rest) but that use ceased some time after the Royal Navy left Rosyth in 1995. The buildings have been used for other purposes since but current plans are to demolish them and build houses on the site.

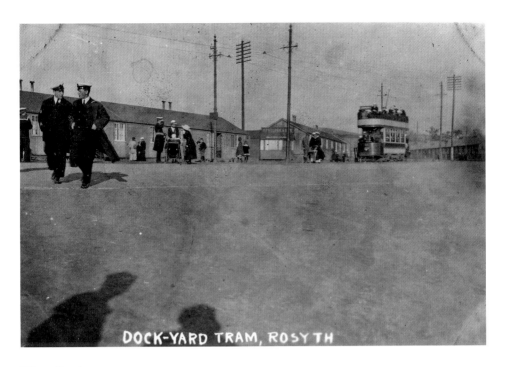

DOCK-YARD TRAM, ROSYTH

Hilton Road

Trams ran between Rosyth and Dunfermline during the years 1917 to 1937. The Rosyth terminus was in Hilton Road opposite the post office and the photo above shows the tram approaching the Rosyth terminus. In the background are some of the huts of Tin Town or Bungalow City, a temporary hut settlement for men building the Dockyard and (later) for men working in the Dockyard and their families. The huts were built in 1913/14 and the ones shown in this photo (in Bungalow City West) were demolished in the early 1920s. The modern photo was taken from outside McColl's shop.

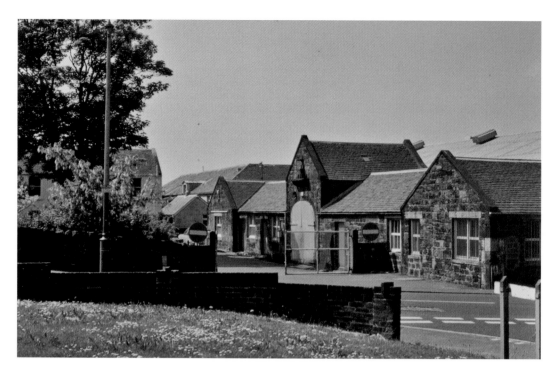

Rosyth Farm

This farm was one of the farms bought by the Admiralty for the construction of the Dockyard. The farm buildings were used by Admiralty engineers during the construction phase and for a variety of purposes after that. What was probably the farmhouse still exists and appears on the left of both photos but the ancillary buildings in the top photo were demolished at the end of 2003.

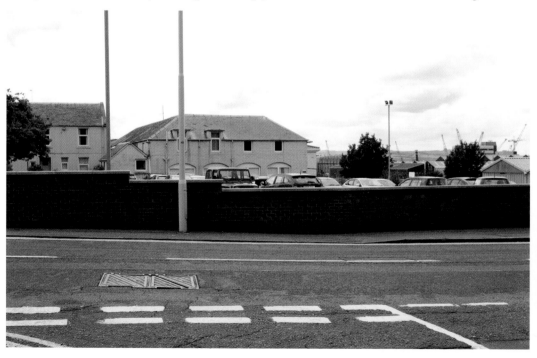

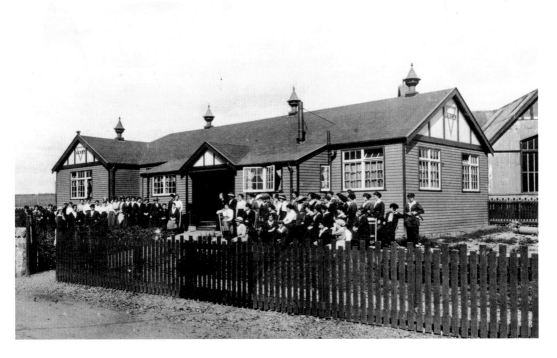

Young Women's Christian Association

The YWCA opened what the Dunfermline Press described as a 'large commodious building' in 1917. It was situated on the north side of Hilton Road, approximately at its junction with Wilson Way. Unlike its male equivalent, the YWCA seems to have been fairly short lived. Behind the building can be seen the Navvy Mission Church.

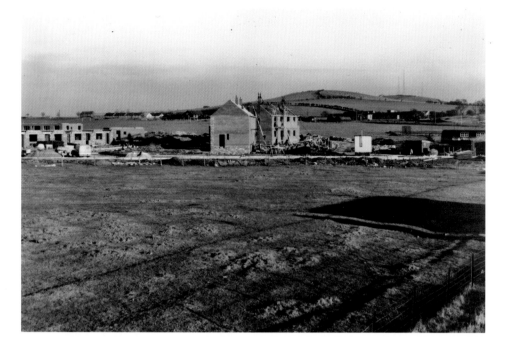

Cunningham Road

We now head back along Hilton Road towards Castle Road. The area to the north of Hilton Road, once occupied by the Tin Town houses, was used for building married quarters in the 1950s. Here we see work starting on Cunningham Road in 1953 with the present-day Forth Club in the distance towards the right-hand edge of the photo. Other houses built in Hilton Road prevented me taking the modern photo from the same position. The houses in the middle of the old photo appear at the left-hand edge of the modern photo. The single storey building on the right of the modern photo is Hilton Court, a care home for people with mental health problems.

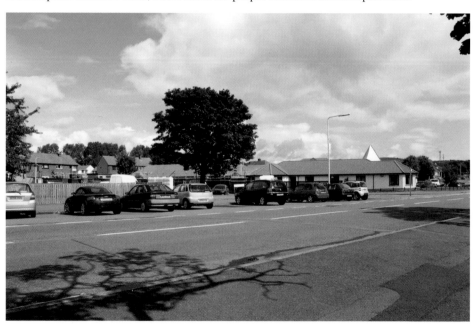

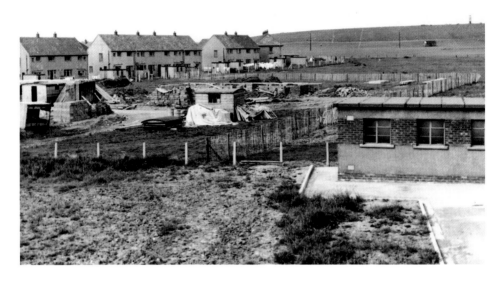

McGrigor Road

This view taken from the Apprentices' Hostel (now The Bridges Centre), shows houses being built in McGrigor Road in 1957. On the skyline at the right edge of the photo is the clock tower which used to stand on Pease Hill for the benefit of the sailors using the Fleet Grounds. On the right of the modern photo is McGrigor House, built about 2005.

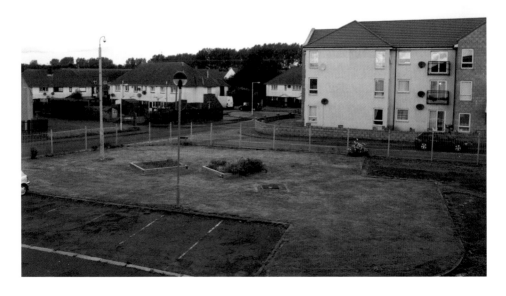

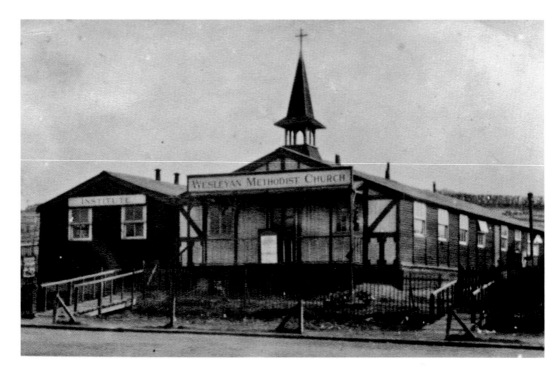

Wesleyan Methodist Church
Castle Road was built by the Admiralty in 1915 as the main access to the Dockyard. This wooden church and institute was opened in 1917 by the Wesleyan Army and Navy Board. It served both the naval and civilian population until 1926 when the Dockyard was closed down and placed on a care and maintenance basis. The building was on the east side of Castle Road near where Rannoch Road is today.

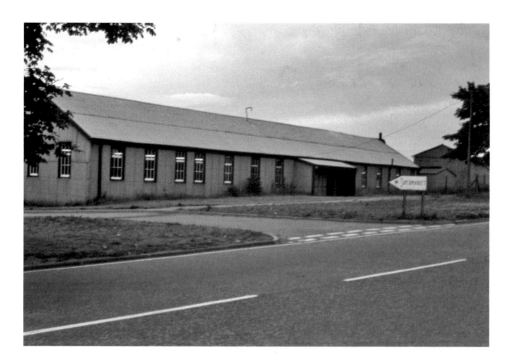

Chart Depot

This was one of the many tin huts put up in the early days of the Dockyard's construction. It served as a club for Dockyard workers for many years and ended its days as the Dockyard's Chart Depot. This photo was taken in 1974 when it was still being used for this purpose. The depot moved to new premises within the Dockyard in 1980 and the building was demolished soon after that. It stood in front of the NAAFI, hence the sign. The site of the depot is this grassy area in front of the Spar shop which is the successor to the NAAFI.

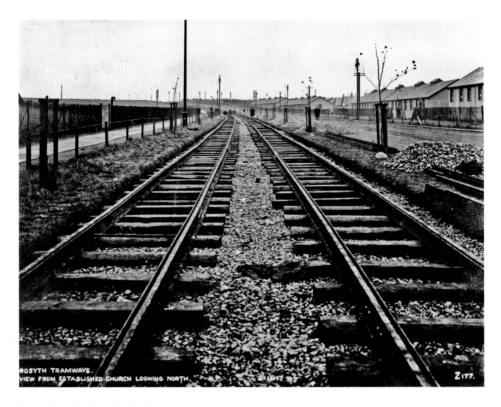

ROSYTH TRAMWAYS.
VIEW FROM ESTABLISHED CHURCH LOOKING NORTH.

Z177.

Tramlines in Castle Road

Taken in 1917, this view from outside the temporary Presbyterian Church looks northwards up Castle Road showing the track for trams travelling from Rosyth to Dunfermline. On the right were tin huts similar to the Tin Town houses which were built to house men building the Dockyard but which later seemed to be used for recreational purposes – meetings, dances, etc. On the left of the photo below is the Peasehill Estate and on the right, houses in James Millar Road. The fire station is hidden by the trees.

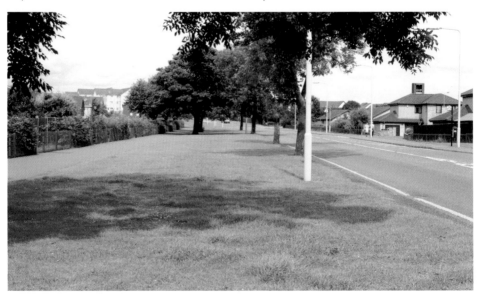

Castle Road and Fleet Grounds

This view from the slopes of Castlandhill was taken in 1973. In the foreground are the roofs of houses in Rannoch Road and the Officers' Club. The Sherbrooke Road estate has not yet been built. The modern view is taken from higher up the hill with the roofs of houses in James Millar Road in the foreground and houses in Peasehill in the distance.

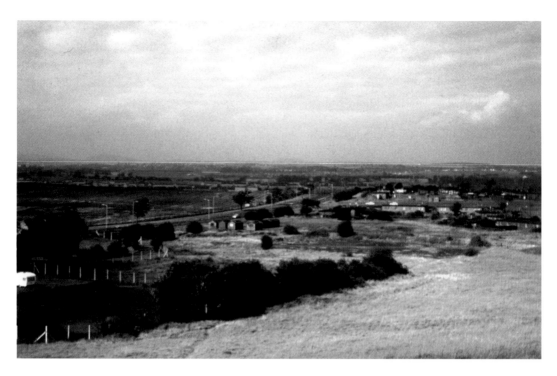

Castle Road and Dollytown

Also taken in 1973, this photo looks more towards the north over Dollytown, much of which had been demolished by this time. The fire station is in the middle of the modern photo surrounded by houses in Mountbatten Place, Granville Way, Shinwell Place and Normandy Drive. The white houses beyond the fire station and to the right are in Boyle Drive.

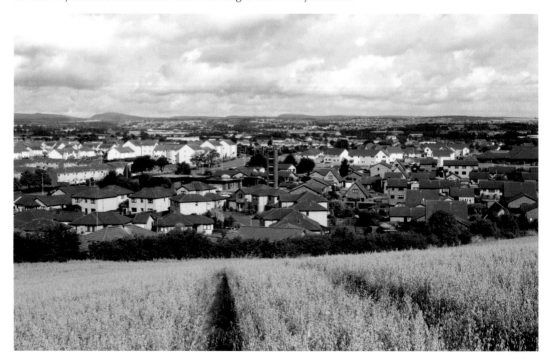

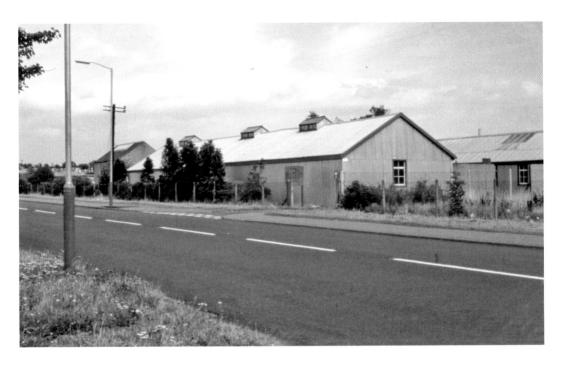

Officers' Club

This old photo of the Officers' Club dates from 1973. It was another of the early buildings erected when the Dockyard was being built. The Officers' Club used the building until 1993 when it became independent of the Royal Navy and was re-named the Jutland Club. After the Club closed in 1995, the building was badly damaged by fire and was demolished. Private houses were built on the site in 2001 and the photo below shows Hood Crescent.

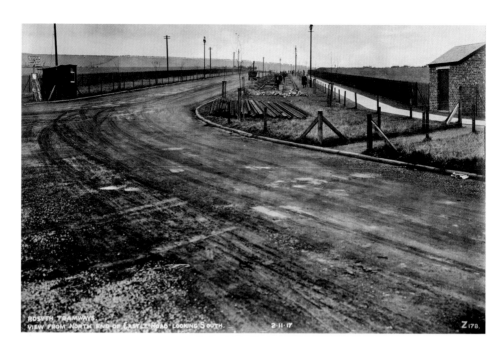

Admiralty Road and Castle Road Junction

This 1917 photo shows the tram lines being laid outside what is now the Civil Service Sports Club. The view is taken from near the roundabout at the top of King's Road and looks south toward the Dockyard. Note the old tar boiler at the centre top of the photo. The sign at the top left-hand edge of the photo (beside the hut) reads 'all heavy motor traffic must avoid running in one track continually'.

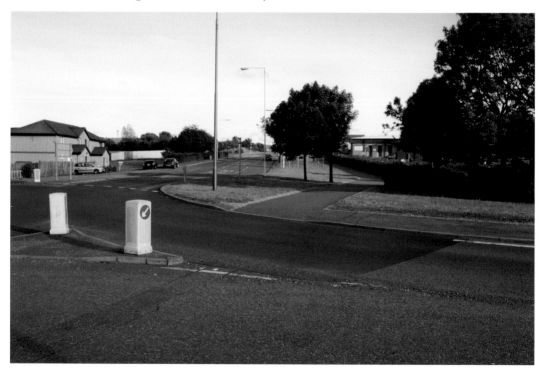

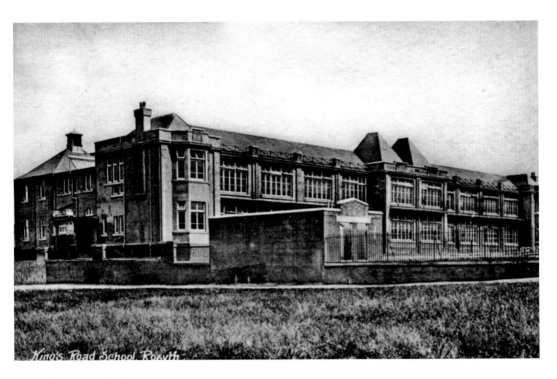

King's Road School

King's Road School was the first permanent school in Rosyth, opening its doors in 1918 to 1,000 pupils, both primary and secondary. After Inverkeithing High School was opened in 1972, it became a primary school. Sadly the school caught fire in 2001 and it was too badly damaged to be restored. The photo below captures some of the drama of that occasion. *(PC by Edwin Reid and photo by Graham Lucas)*

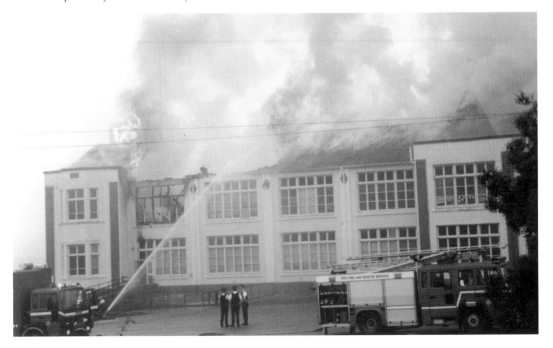

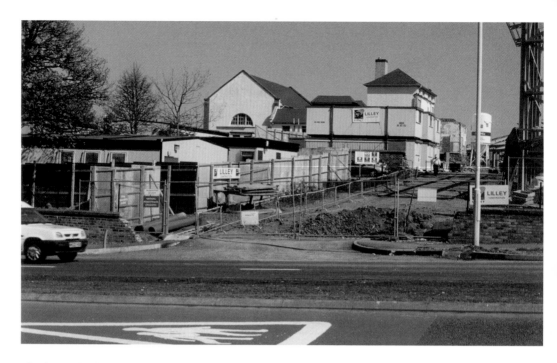

King's Road School Reborn

After the fire in 2001, most of the school was quickly pulled down for safety reasons. The gymnasium and adjoining block were largely untouched by the fire and were left standing while decisions were taken about the future of the school. It was eventually decided to build an entirely new school requiring the demolition of these blocks. However, they survived long enough to witness the framework of the new school rising from the ashes as can be seen from the photo above taken in 2003. The new school opened to pupils in 2004.

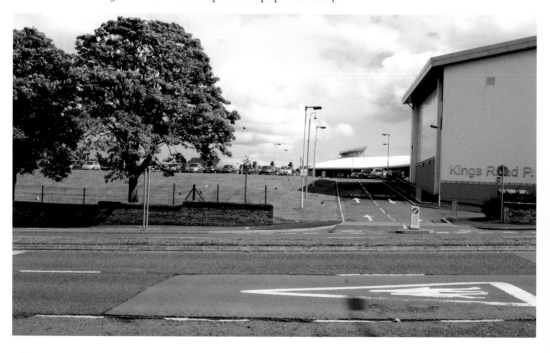

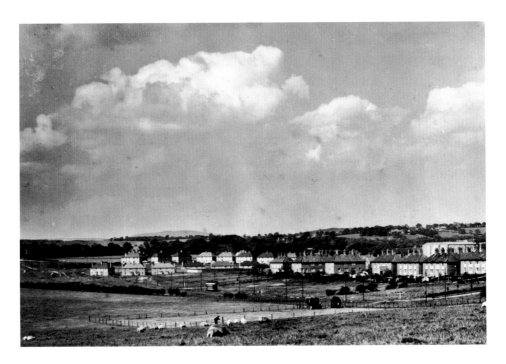

Kings Road and Tram

Taken from the Glasgow Road near where the former Lexmark factory stands today, this view looks towards King's Road. It was probably taken in the late 1920s and King's Road at that time did not exist except on paper. Running along the line of what was to become King's Road were the tramlines and a tram can be seen towards the left of the photo. The houses in the photo are the backs of houses in King's Place and Albert Street and at the left-hand edge are houses in Park Road. The fenced off area in the foreground was probably a putting green opened in 1922 as a private enterprise. This is roughly the location of Camdean School.

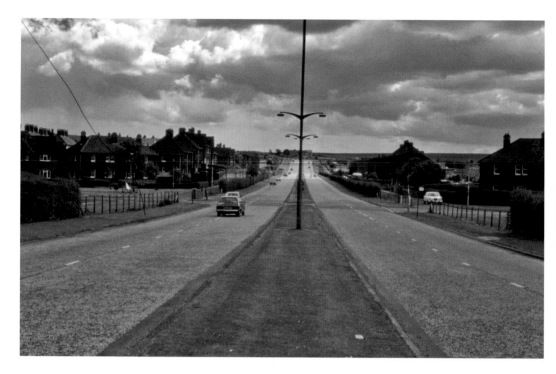

King's Road looking South
This rather atmospheric photo was taken in 1980 before the roundabout was built at the Park Road junction. In recent times, the central reservation and verges have been planted with bulbs and more have been planted this year. The photo below, taken earlier in the year, shows the mass of crocuses which gave a colourful but all too brief display.

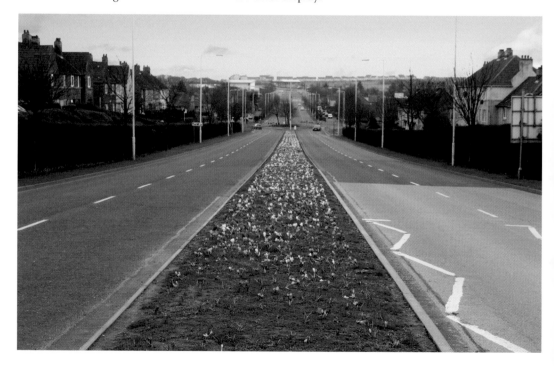

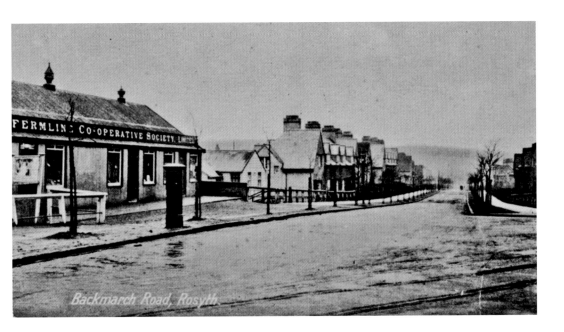

Backmarch Road, Rosyth.

Backmarch Road

This was one of the first roads to be constructed in Rosyth Garden City. The temporary Co-op buildings shown here were opened in 1917, providing butcher, grocery, bakery, drapery and boot shops. The building was demolished in about 1962 and a permanent building was erected in its place by the Co-op. It went through a number of different ownerships, finally being demolished in 2008. This year, four small shop units were erected on the site set well back from the road to allow for car parking (see inset in lower photo). Coincidentally, one of the units is occupied by The Co-operative Funeralcare.

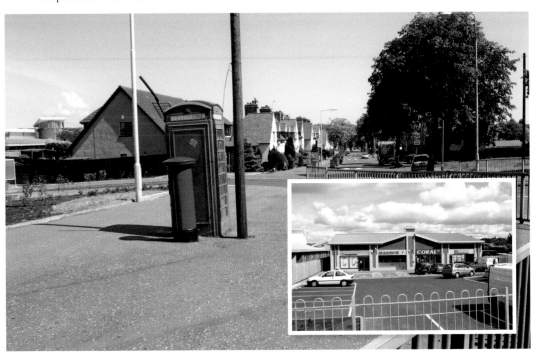

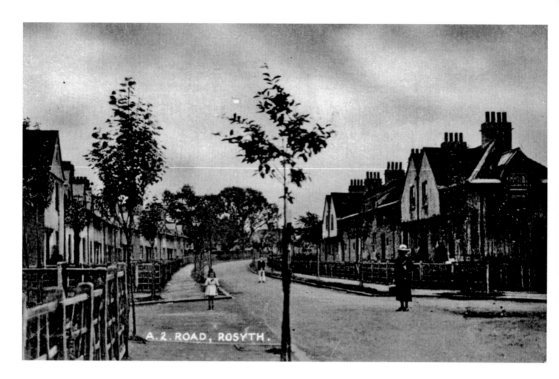

A.2. ROAD, ROSYTH.

Norval Place

Before street names were allocated in Rosyth, streets, etc. were known as A1, B2, etc., with the letter indicating the building phase. Norval Place was in the first phase, hence its designation A2. Backmarch Road was A1. This view is taken from its junction with Backmarch Crescent looking south towards Admiralty Road. Note the concrete kerbstones in the modern photo below. Sadly these have replaced the original stone ones which are a feature of the original Garden City streets.

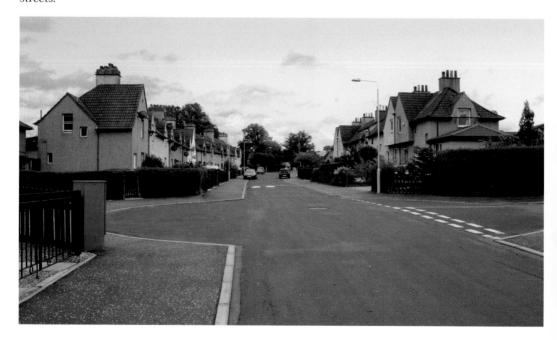

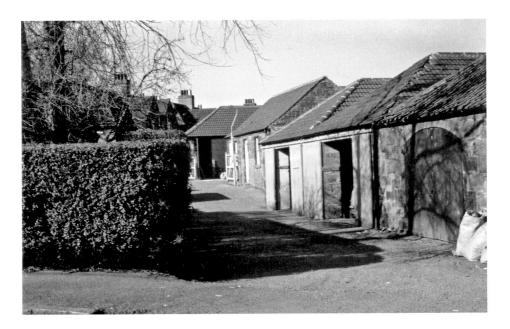

Backmarch Steading

Backmarch Farm was another farm purchased by the Admiralty as part of the land required for the building of the Dockyard. The farmhouse and steading still exist in Norval Place. Parts of the steading have been put to a variety of uses over the years, including a fire substation, a library, a church, a scout hall, a garage for refuse lorries, and a maintenance base for the Scottish Special Housing Association. The photo above shows the steading as it was in 1975. In 2002 the steading was converted into houses and, as can be seen from the photo below, some demolition was required to provide suitable access. This is now called Charles Logan Place after a former Rosyth Councillor.

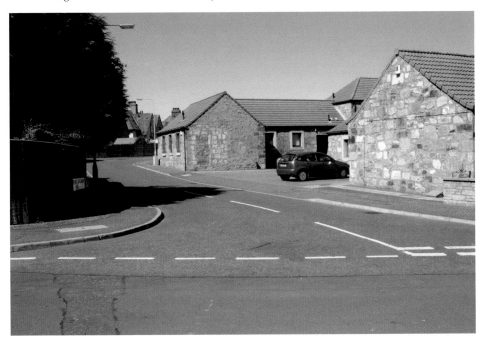

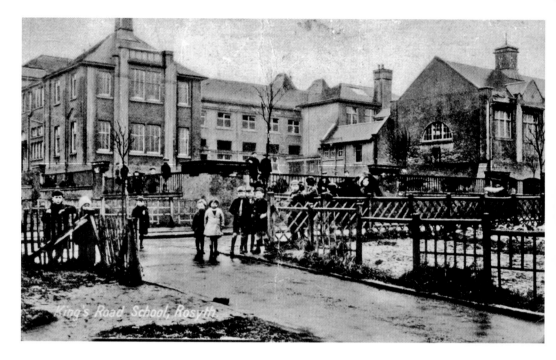

King's Road School, Rosyth.

King's Road School and Pupils

This photo was probably taken about 1920. A photo being taken in public with the old-fashioned equipment of the time must have been a real novelty and the children were curious to see what was happening. I recreated this scene with the help of present pupils at the school who were not at all fazed by a camera (or me!). Although the school building in the background has been replaced, the boundary walls and railings remain substantially the same as when the school was first built.

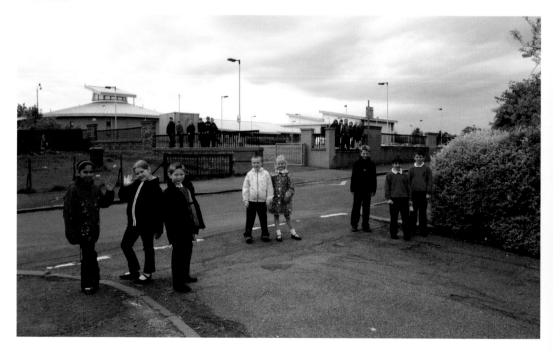

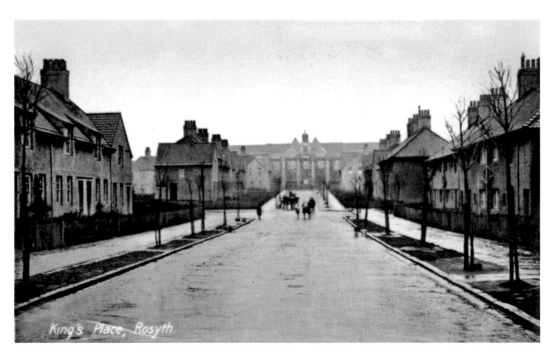

King's Place, Rosyth

King's Place

This is a view south along King's Place with King's Road School at the end. It was taken about 1920. Noticeable in the modern photo below are the numerous cars parked on both sides of the road, the speed hump, the more mature trees, and the replacement school building.

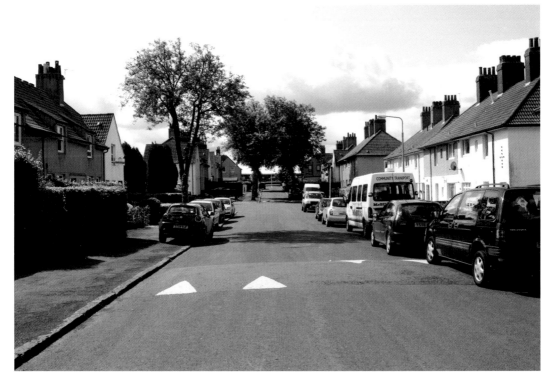

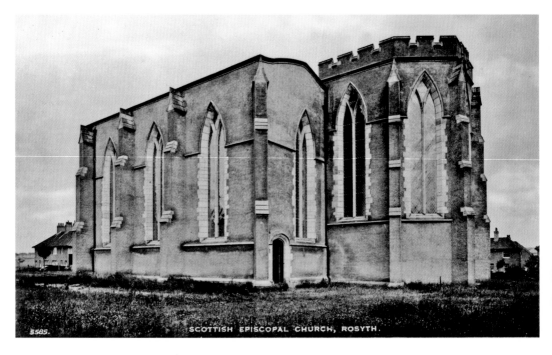

St Andrew & St George Scottish Episcopal Church
This church was under construction in 1926 when the decision was taken to close the Dockyard. A large percentage of the congregation were Dockyard workers from England who were forced to return south because of the closure. The church was opened that year but on a smaller scale than previously planned. The building was demolished in 1986 and a small housing estate (Mellor Court) was built on the site. *(J. B. White PC)*

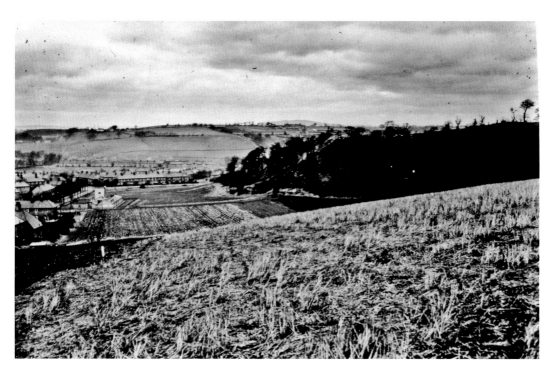

Forth Road Bridge Approach Road

We move to the east side of Rosyth for the next group of photos. This view was taken in 1962 and shows the route to be taken by the approach road to the Forth Bridge. The houses on the left are in Fairykirk Road and Admiralty Road. The modern view below was taken from the bridge joining Castlandhill Road to the west side of Inverkeithing.

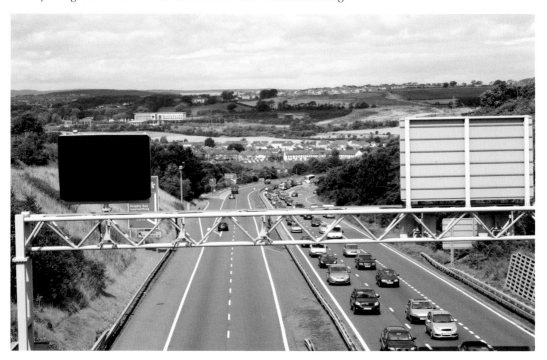

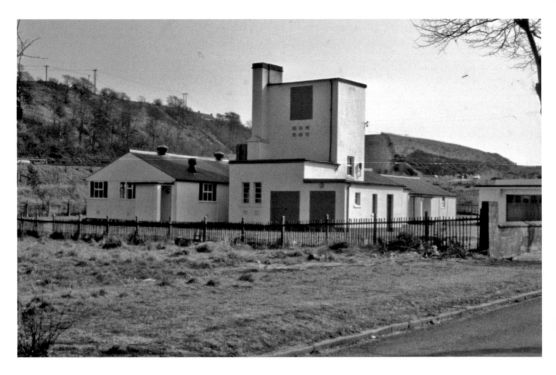

School Meals Kitchen
This building was located in Fairykirk Road. As its name implies, it was used for the centralised cooking of school meals. It was demolished in 1984 and an office or factory unit has now taken its place.

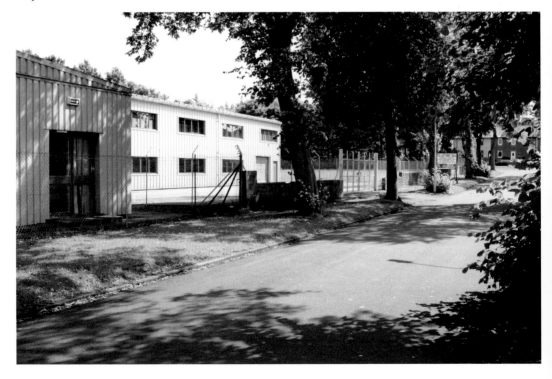

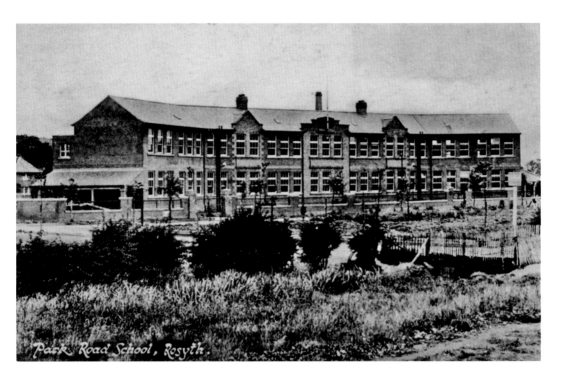

Park Road School

The school was opened in 1922 with a roll of 750 pupils. This photo was probably taken fairly soon afterwards. Outwardly not a great deal has changed apart from the disappearance of the flagpole and the painting of the exterior. In the right foreground of the old photo is the bridge carrying Harley Street over the burn. The bushes which have grown up along the burn prevented me from taking the current photo from the same spot. *(Herbert's PC)*

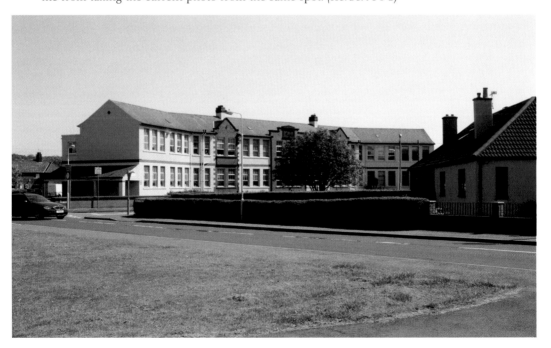

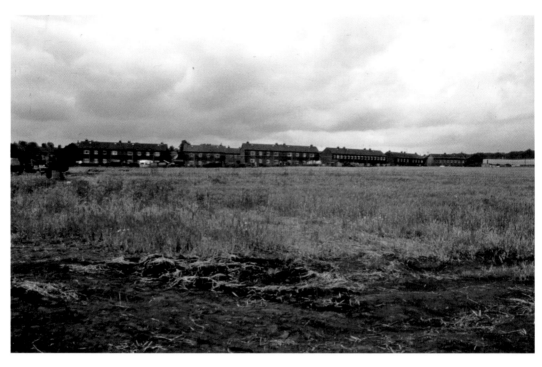

Park Lea
This was the first of a number of small private housing estates to be developed in Rosyth. This photo was taken in 1981 from near the motorway fence and looks across the field to the backs of houses in Burnside Crescent.

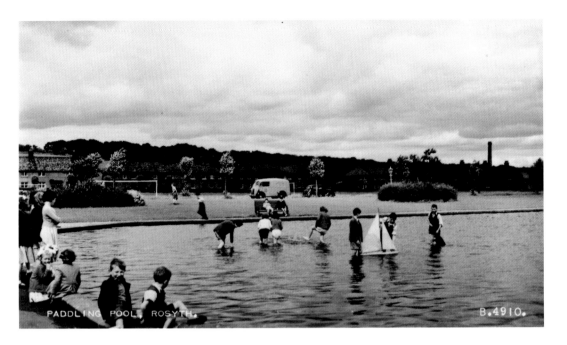

Paddling Pool

Rosyth Garden City was largely complete by 1918 but it took many years before the area designated for a public park was ready for use. The paddling pool was opened in 1938 and many of the older generations will have happy memories of paddling or bathing in the pool. This photo dates from about 1950 when the Brickworks' chimney on the right was a dominant feature. The paddling pool has now been designated a boating pond and, during the period April to October, is used by the Rosyth Model Ship Club. The photo below was taken during one of their sessions. *(Valentine's PC)*

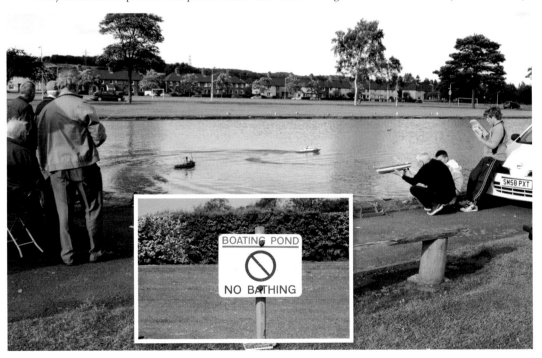

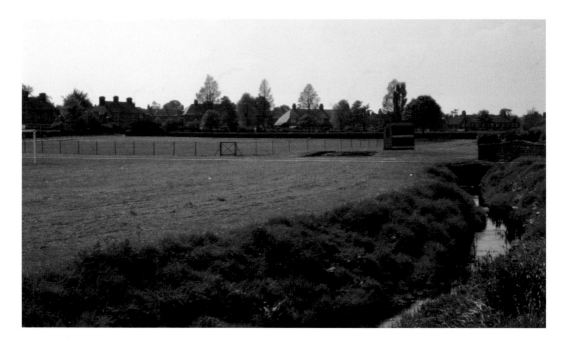

Putting Green

Many people will remember the putting green and tennis courts in the public park which were enjoyed by young and old alike. I didn't think I had a photo of them but came across this one in my own archive taken in 1978. The putting green is surrounded by a fence and the balls and putters were obtained from the little wooden hut just to the left of the hump-back bridge. A new children's play park was opened on the site earlier this year with rather more sophisticated items of equipment than were available in my childhood days.

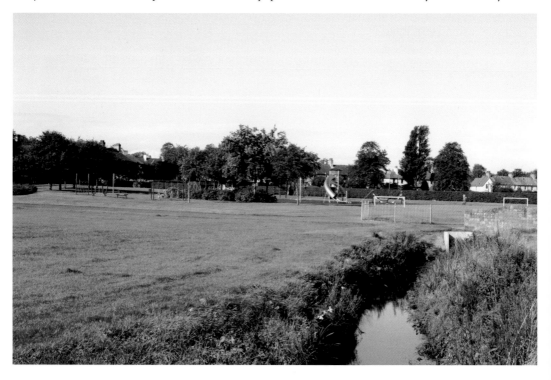

Woodside Avenue/Middlebank Street Junction

For many years after Rosyth Garden City was built, the land along the north side of Woodside Avenue was undeveloped. This was the edge of the Wilderness Woods. In the early 1950s, individual houses (mostly bungalows) were built along this side of the road starting at the west end. These stopped short of the end of Woodside Avenue leaving this strip of ground between Woodside Avenue and Middlebank Street, which latterly was used as a garage site. This photograph was taken in 1984 shortly before Robertson Homes built these houses.

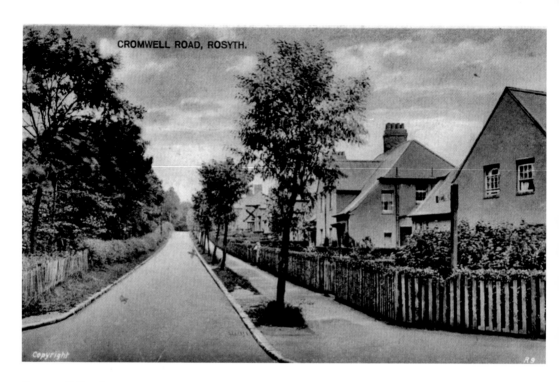

CROMWELL ROAD, ROSYTH.

Cromwell Road

This photo probably dates from about 1930. A belt of trees (a spur off the Wilderness Woods to the north) occupied the ground between Leslie and Cromwell Roads for many years. These were only removed when the bungalows were constructed in about 1953. The remains of this woodland spur can be seen next to the Health Centre in Park Road.

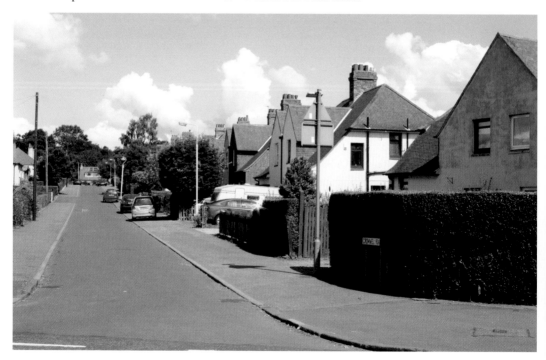

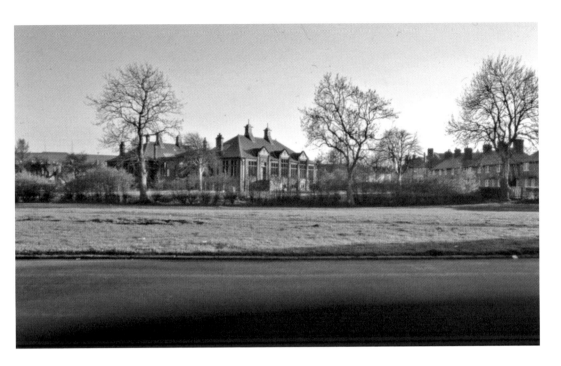

Social Work Offices

For a town of its size, Rosyth had very little in the way of public buildings and the Social Work Offices opened in 1982 were the first Council offices to be provided in Rosyth. This photo was taken the year before and shows the grassy area on which the offices were built. This was separated from the main part of the public park by the burn but was used as an informal area for football etc. The remainder of this grassy area was taken up by the Health Centre, opened in 1983.

Wemyss Street

This stub end of road off Wemyss Street led into the western part of the Wilderness Woods. For a period before this photo was taken in 1982, there were wooden garages in the woods but these (and a large number of the trees) were removed to allow the building of this small housing estate (Wemyss Court) in 1983.

Fraser Road and Churchill Road in Dollytown

Dollytown was built in 1942 to provide housing for workers in the Dockyard who had been posted to Rosyth from southern Dockyards. About 650 houses were built in a remarkably short space of time. The name 'Dollytown' seems to have derived from the fact that the houses appeared to be quite small and were of simple construction. Taken in 1970, this view from Pound Road looks over Churchill Road to Fraser Road. When the Dollytown estate was redeveloped, this was left as a green area.

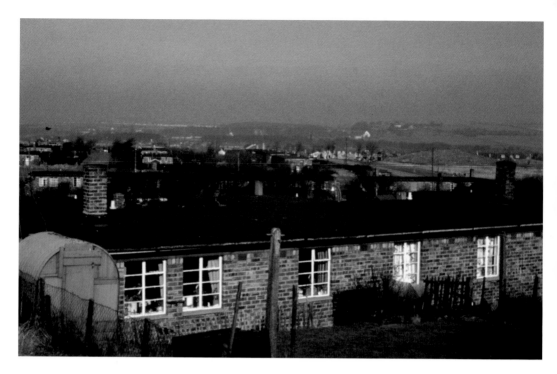

Dollytown: Going, Going, Gone

I was born in 82 Fraser Road in Dollytown, which was in the cul-de-sac at the west end. This is a view from the back garden of my house looking roughly northwards. It was taken in 1973, many years after my family had left the house. By then the redevelopment of Dollytown was underway and some new houses can be seen at the north end of Heath Road just to the right of centre of the photo. The view below was taken in 1975 by which time the Dollytown houses had been cleared west of Heath Road. New houses (probably in Ramsey Place) can be seen to the right of the photo.

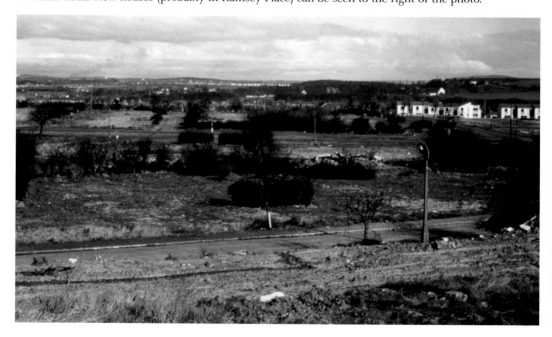

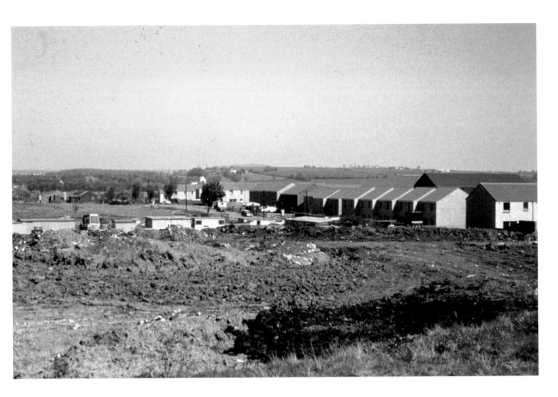

Dollytown redevelopment

These two photos are taken from a similar position to the ones on the previous page. The red roofed houses of Churchill Place can be seen in the one above taken in 1977. The houses are largely obscured by trees in the modern one below. The building in the centre of the photo is St John's RC Primary School opened in 1988.

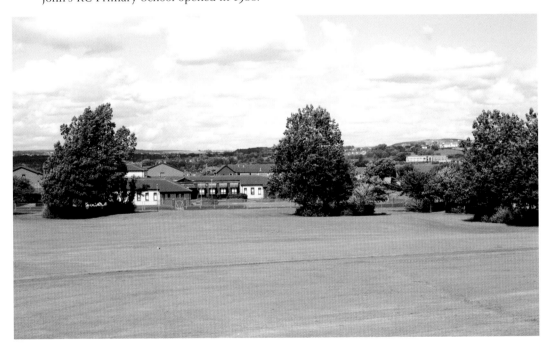

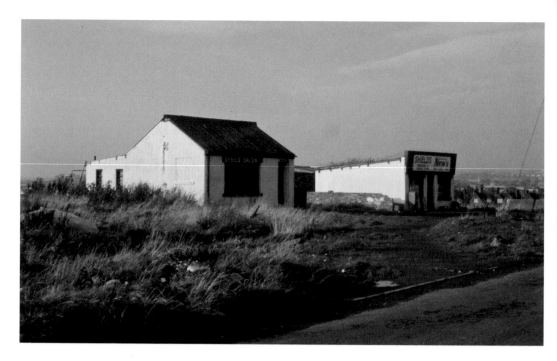

Shops in Heath Road, Dollytown

These two shops served some of the needs of the residents of Dollytown for many years. I believe one was a converted Second World War air-raid shelter. This photo of the shops was taken in 1978 when the surrounding Dollytown houses had been demolished, hence their apparent isolation. The one on the left was Sybil's Salon and on the right was Shields' Newsagent and General Store. These two shops were replaced by the Gladyer Inn buildings, opened at the end of 1983.

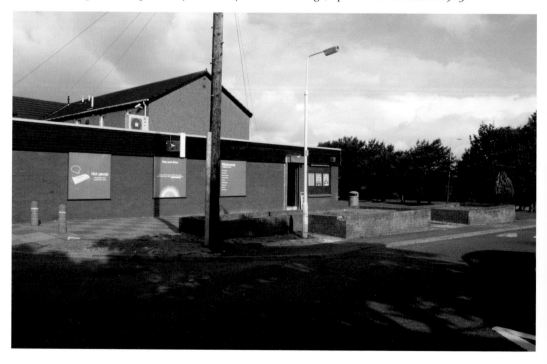

Prefabs in Camdean Crescent

We move now to the west side of Rosyth and a photo of prefabs in Camdean Crescent taken in 1971. These were part of an estate of fifty prefabs built in the Park Road West and Camdean Crescent area in 1948/9. The scheme was demolished in 1975 and three years later the site was sold off as feus for individual houses.

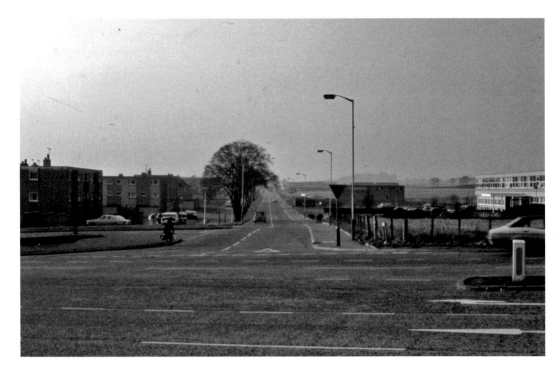

View along Primrose Lane

This view along Primrose Lane was taken from Queensferry Road in 1974. Not a great deal has changed on the left-hand side of the road but the area on the right has altered considerably, as can be seen from later photos. On the right edge of the old photo is the Lyle & Scott factory, opened in 1962. The petrol filling station in the foreground of the bottom photo was built in 1993.

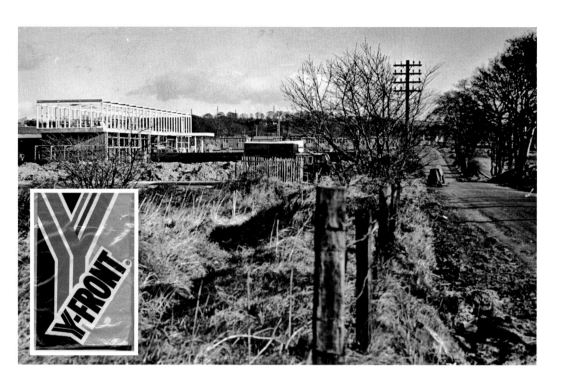

Lyle & Scott in Primrose Lane

This 1962 photo was taken in Primrose Lane looking east towards Queensferry Road. The Lyle & Scott factory is under construction on the left side of the photo. *(Photo by J. Wright)* The building of this factory was something of a landmark occasion for Rosyth as, prior to that, the only major employer in the area was the Dockyard. Lyle & Scott were famous for making the well-known Y-front range of men's underwear (see inset). The Primrose Gardens housing estate now occupies the site.

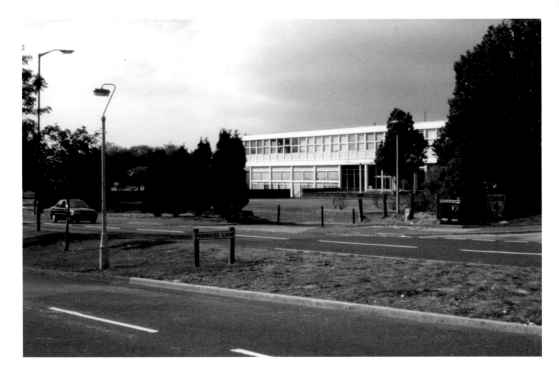

Roller Bowl

After the Lyle & Scott factory was closed, it was bought and operated as a tenpin bowling-alley, etc. under the name 'Roller Bowl'. It opened in 1990 but was badly damaged by fire in 1992. It then lay derelict until further damaged by fire in 1996. The photo above was taken in 1995. In 1997, Champions opened a similar type of centre which latterly operated under the name of the 'Leisure Zone'. The photo below is of the centre in 2005, shortly before its demolition.

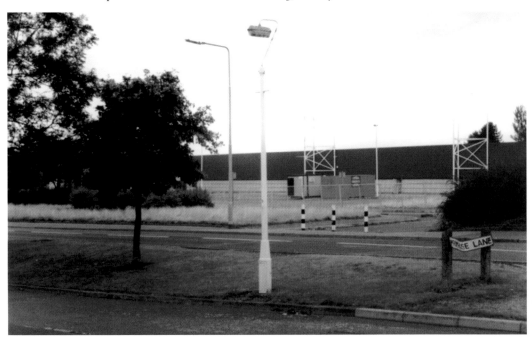

Primrose Gardens and Medical Centre

The Leisure Zone building was demolished in 2006 and the Primrose Gardens estate of private houses was erected by Thomas Mitchell Homes. Further west along Primrose Lane on a site adjoining the housing estate, the Primrose Lane Medical Centre was opened in 2000 (see below). This centre houses the GPs' surgery, which used to operate from premises in Queensferry Road. The Vetrica Veterinary Surgery also operates from the centre.

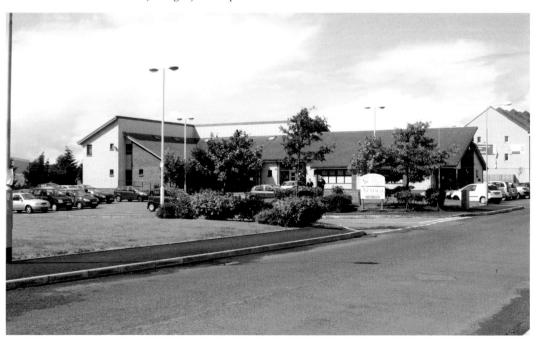

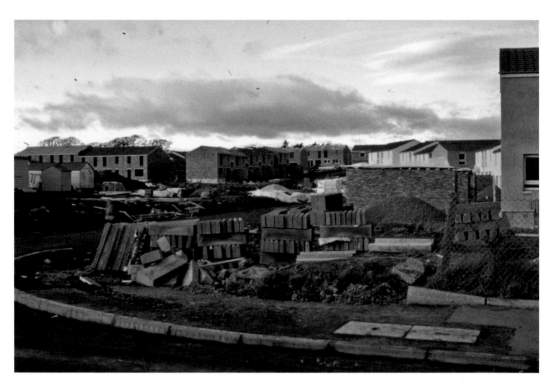

Syme Place

This view is from part-way up Syme Place looking north and was taken in 1975. Unfortunately, in the modern photo below, the trees mask the view of a lot of the houses featured in the old photo.

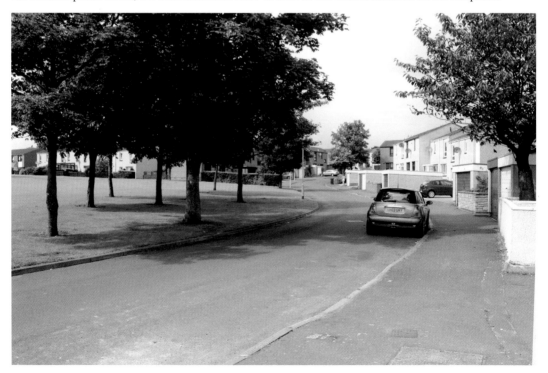

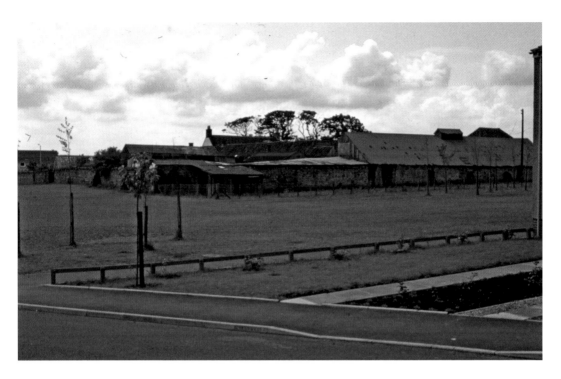

Primrose Farm

This is Primrose Farm as seen from Syme Place in 1978. The area around the farmhouse was completely cleared of the outbuildings in 1989 and the housing estate known as 'The Byres' took its place.

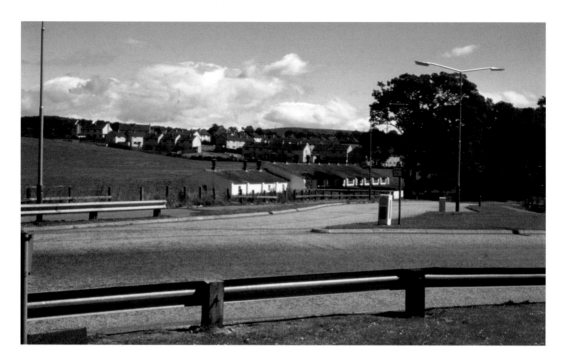

Entrance to Pitreavie Castle

We now move to the Pitreavie Castle area. Before Dunfermline's Eastern Expansion, Pitreavie's connections were with Rosyth rather than Dunfermline, with primary school children from the married quarters attending Park Road School. This was the entrance to Pitreavie Castle in 1978. The buildings on the left side of the road were, I think, a gymnasium and squash court. In the distance are the married quarters.

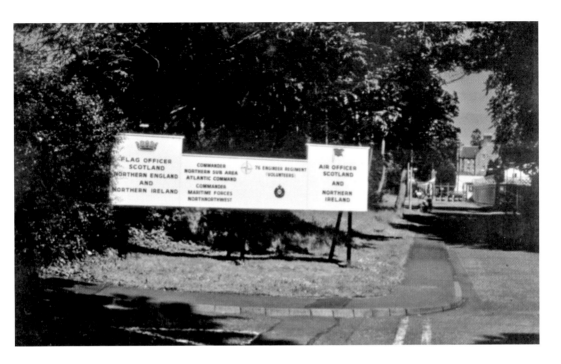

Pitreavie Castle

Pitreavie Castle was bought by the Air Ministry in 1938 and became the headquarters of 18 Group Coastal Command. The castle can just be seen through the trees. An underground bunker was completed in 1941 housing the Maritime Headquarters with Royal Air Force and Royal Navy staff working in close cooperation. This notice-board lists the various Commands as at 1995 when the base closed.

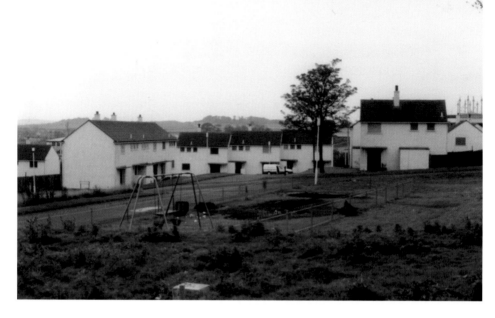

Pitreavie Married Quarters

As one might expect in a military establishment, there were two sets of married quarters – one for officers and one for the other ranks. This is the 'other ranks' estate, which could be seen in an earlier photo. I don't have accurate enough plans to precisely relate the old photo to the present day but this view in Maclean Walk is an approximation of where the early married quarters were situated. The top of the Dunfermline Building Society's headquarters can be seen on the right-hand edge of both photos. The above photo was taken in about 1995 when the RAF and Royal Navy had moved out of Pitreavie Castle. *(Photo by Bill Woodhead)*

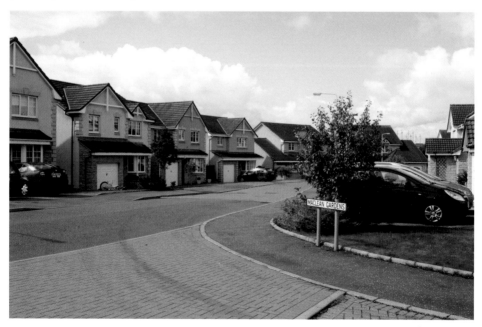

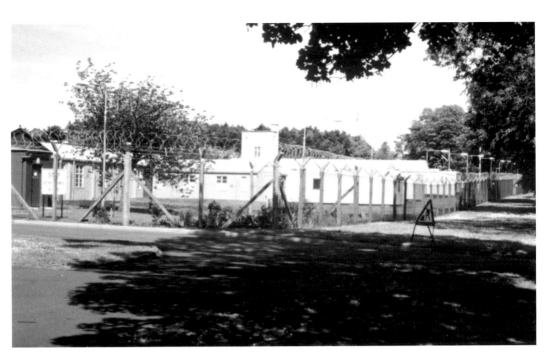

Buildings in Pitreavie Castle Area

I am afraid I don't know the purpose of these buildings behind the security fence. In the final years of the base, the eastern portion was used as the headquarters of HMS Scotia, the Royal Naval Reserve. The site of these buildings is now a settling pond in front of the Centrex Conference Centre and Optos buildings seen in the photo below.

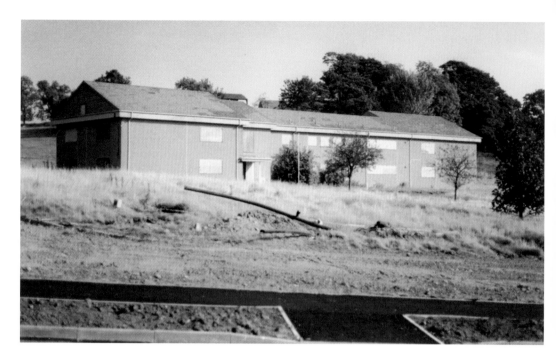

NATO Communications Centre

According to a press report, this centre was built in the 1970s to add the latest technology to the NATO nerve-centre in the underground bunker at Pitreavie. From this building, top-secret coded messages were sent all over the world. This photo was taken in 1998, some three years after the building had ceased to be used. The building was demolished in 1999 but not without some difficulty as the walls were two-foot-thick reinforced concrete. Again, without accurate maps I cannot relate this building exactly to the present day but it would be roughly where Dovecote Wynd stands today.

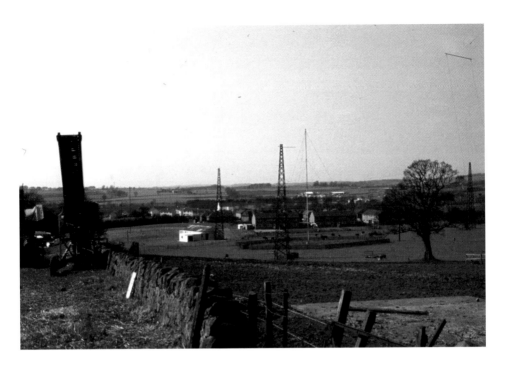

Pitreavie Castle Radio Masts

The photo above was taken from the Masterton Road in 1974 and shows the radio masts associated with the Maritime Headquarters at Pitreavie Castle. The houses behind the masts are in Blackwood Green, the officers' married quarters. I found it impossible to take equivalent modern views of this photo and the one on the next page because of the thick shelterbelts and screening associated with the housing estate now built on the site. The bottom photo is taken in Dovecot Way from a point in the housing estate which is probably fairly close to the wall shown in the upper photo.

Pitreavie Castle Area

This is a much later view (1995) than the one on the preceding page and was taken from a point further north. At that time there was no road linking Masterton Road with the Rosyth/Dunfermline dual carriageway, only the path which lies to the north of the present Carnegie Drive. The path is on the opposite side of the hedge line at the right-hand edge of the photo. The work taking place on the other side of the fence is the building of the Heathery. The houses are the married quarters in Blackwood Green. As I could not take a modern view from the same spot, I have used the photo below, taken in 2001, to illustrate the significant changes that have taken place.

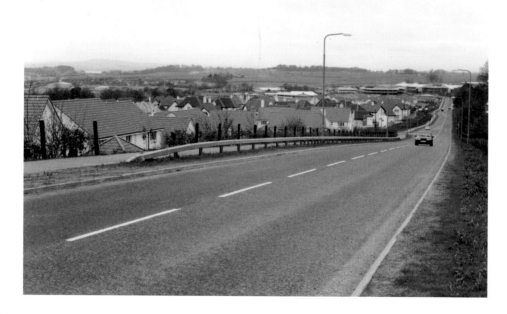

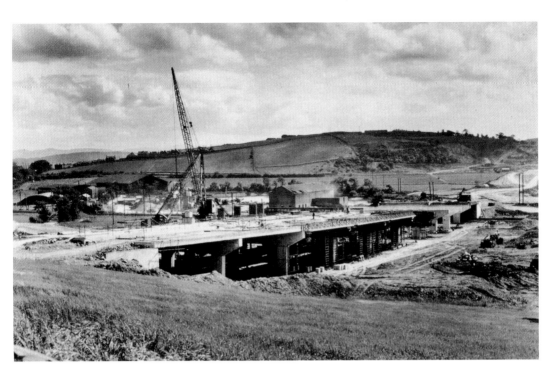

Masterton Flyover on M90

The M90 motorway can lay claim to being the first section of motorway in Scotland, albeit that its first phase was less than two miles long. It was constructed as part of the northern approach roads to the Forth Bridge. This photo is a view from the north showing the Masterton Viaduct under construction in 1962. This was the scene of a serious accident that same year when the viaduct collapsed killing three men.

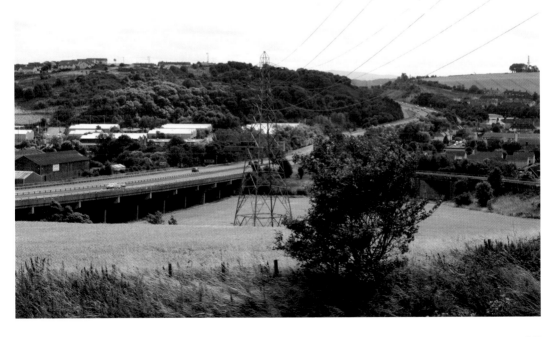

Acknowledgements

Most of the old images used in this book have come from my own collection of postcards and photographs or have been taken by me. The other main source has been the Local History Collection at Dunfermline Carnegie Library and I am grateful to Fife Council Libraries & Museums for their permission to use the photos on pages 6, 9, 10, 14, 17, 18, 20, 24, 34, 37, 41, 56 and 83. My thanks to Janice Erskine and the library staff for their assistance. A number of the photos have come from the collection of Alan Brotchie of Aberdour, including some particularly good quality ones which have very much enhanced this book. My sincere thanks to Alan for allowing me to use these photos on pages 22, 26, 33, 59 and 64.

I am also grateful to YMCA Scotland who kindly allowed me to reproduce the view of their Institute and Hostel in Ferrytoll Road on page 44, and to a number of individuals who have allowed me to use photos in this book – Donald Blow (page 12 inset), Mrs Janet Dalrymple (page 28), Mrs Jennifer Galloway (page 39), Graham Lucas (page 57), and Bill Woodhead (page 90).

All the modern photographs have been taken by me using my new digital camera bought for the occasion. In some of the photos, I have tried to recreate scenes in old postcard views. I am grateful to Elliott O'Riordan; pupils of King's Road School; and the staff of the Parkgate Community Centre for acting as my 'models' in three of the photographs and to the Rosyth Model Ship Club for allowing me to photograph their session on the boating pond.

Last, but by no means least, a special thank-you to Sandy Masterton for all his help and encouragement. He has played a significant part in the production of this book by scanning most of the old photographs I have used (and a number I didn't).